Middle East Affairs

War Adventures of Zahos Hadjifotiou in Tobruk, El Alamein and Rimini

ZAHOS HADJIFOTIOU

Copyright © 2016 Zahos Hadjifotiou
All rights reserved

DEDICATION

Dedicated to my comrades
fallen on the field of honour

MIDDLE EAST AFFAIRS
War Adventures of Zahos Hadjifotiou in Tobruk, El Alamein and Rimini
ZAHOS HADJIFOTIOU

Third edition

ISBN-13: 978-1-910370-82-7 (assigned to Stergiou Limited)
ISBN-13: 978-1-534906-37-2 (assigned to CreateSpace)
e-Pub ISBN-13: 978-1-910370-83-4 (assigned to Stergiou Limited)

Copyediting: CreateSpace, an Amazon company
Cover: Constantine Leftheriotis

Published by Stergiou Limited
Suite A, 6 Honduras Street
London EC1Y 0TH
United Kingdom
Web: http://stergioultd.com
Email: publications@stergioultd.com

First edition in Greek: October 1997
Second edition in Greek: November 1998
First edition in English: Athens 2001 (ISBN: 960-8172-13-6)
Second edition in English: London 2015 (ISBN: 978-1-910370-61-2)
Title of first and second edition: Love & War

No part of this book may be reproduced in any form by any electronic or mechanical means including photocopying, recording, or information storage and retrieval without permission in writing from the author or the publisher.

Copyright © 2016 by Zahos Hadjifotiou

All rights reserved.

CONTENTS

Love And War	Pg. 7
The Desert Rats	Pg. 14
The Man I Love	Pg. 30
Soldiers Only Fight	Pg. 46
The General's Daughter	Pg. 63
On The Way To Rimini	Pg. 80
Jour Fixe	Pg. 93
Crossing The Rubicon	Pg. 104
Cigarettes And Perfumes	Pg. 117
Athena's Head	Pg. 133
In Athens At Last	Pg. 147
The Return Of The General's Daughter	Pg. 165
About The Author	Pg. 172
Book Review (*Kirkus Reviews*)	Pg. 173

LOVE AND WAR

At the head of the table sat the school's headmaster. To his right was the professor of modern Greek, and next to him was the math teacher. Directly opposite sat Mr. Peet, the English professor who had become the headmaster's assistant.

The subject at hand: my expulsion.

The headmaster was of two minds. He awaited the opinion of the math teacher, who would accept no extenuating circumstances in my case.

"Unruly, arrogant, a bad pupil, and a bad influence on other pupils," he said.

"Nevertheless," said the modern Greek professor, "in my twenty-five years' experience I have never read more beautiful essays and more interestingly expressed ideas than from this particular pupil."

At this point, the headmaster wavered, but then came cruel Mr. Peet's head-on attack:

> "To write pretty stories or jump higher and further than other pupils does not constitute a good enough reason to keep in our school a pupil who does not

follow the curriculum. He is undisciplined, insolent, and, as my colleague quite rightly says, a bad influence all around."

Unfortunately, Mr. Peet's word prevailed.

So my poor mother had to find another school that would accept me with the hope that I would graduate, so as to acquire a paper in hand for a "rainy day." This was a favorite sentence of hers, as she had a bad premonition about my future.

I came last in a class that produced twelve university professors, but I did graduate.

That rainy day came sooner than expected. In three months' time, Italy attacked Greece, and at the end of six months, the Germans marched into Athens as conquerors.

Sorrow, the menace of the Germans, the prospect of famine, and needless to say the life imposed by a foreign occupation were far from suitable for a young man of my nature. I was rebellious, unyielding, adventurous, and even a little opportunistic.

Athenian life had come to a standstill. Nightclubs and bars were shut down. Due to strict censorship, only some boring theater matinees and movie houses showed dull German films. Both venues having lost their clientele, the movies played in empty rooms…and I was confined at home due to a midnight curfew!

All this led me soon after to seek out another way of life. "Where will you go?" my mother kept asking me in despair.

"You are only seventeen years old. What do you know of life and its dangers? All around us a vicious war is underway. Where do you think you are going?"

"I will go there; I will go to war," I answered with determination. "I will have a better chance of survival. The Germans will surely kill me here. I have already been caught twice after curfew hours."

She shook her head, my poor mother. She said, "But whom have you taken after?"

This was the most grotesque of her confused remarks. Here I was leaving at seventeen to join a savage war, and all she was trying to find out was who in the family I had taken after!

It was not long before my decision materialized. It only took me a week to organize an escape with some others of similar views. The following Sunday, the last one of May 1941, at noon, we left by train for Lavrio,[1] where we boarded a prearranged *caique*[2] at night. We avoided the German patrols, as it was after curfew hours. The next day, we arrived at Tinos Island, and from there we reached Mykonos Island after a rough passage.

Some islanders joined us there, and we sailed for Samos Island in very bad weather conditions. The following morning, in Samos Vathi, I was walking to a kiosk to buy a newspaper and some cigarettes when an Italian officer arrested me. He decided that my face and attire looked suspicious; the clothes did not resemble those of a local. He marched me to the Commando Tapa Kommandatur, where I escaped through the toilets onto the roof and jumped to the house next door.

Eventually, I met up with my companions, and we immediately set out on foot to the other side of the island, facing Turkey. We walked all night through fields, olive groves, and pine forests, avoiding Italian and German patrols. Around three o'clock in the morning, we reached a small bay where a boatman with his rowing boat, as again prearranged, waited to take us across to Turkey. The distance to the Turkish shore was no more than a mile, but every fifteen minutes, a German torpedo boat with her searchlights patrolled the area for any vessels that would help Greeks to escape.

Soon enough we heard the roar of the patrol boat's engine from

1 *A harbor south of Athens*
2 *A small island fishing boat*

behind the headland. We fell to the ground silent and hid behind the bushes and rocks.

"Heads down, and don't even breathe," murmured the boatman.

The beam of the searchlight danced to and fro as it scanned the stormy sea. At one point, the beam seemed to brush the tip of the prow of our boat.

"Holy Saint Nicholas," whispered the terror-stricken boatman.

This was only the beginning of the war dangers I was to experience, and it triggered the realization that each person's life hangs from a thin thread. Had the sailor handling the searchlight moved it an inch farther in our direction, we would all have been trapped. The sentence: death by firing squad.

Finally, with a sigh of relief, we saw the patrol boat leave the area. We then decided to split into two shifts to man the four oars. The first shift would row halfway down the strait, and the others would follow. Being a featherweight, I wasn't even picked as a deckhand. I was simply to get out, untie the boat, and jump in again. It all happened so fast that I almost found myself in the water.

"Hold tight, hey hop," said the boatman giving the rhythm.

The crew of the first shift rowed like savages. For the first time, I saw a boat cut six miles without an engine. The waves grew bigger and fiercer, and it seemed doubtful that we could get through the strait in less than half an hour. After fifteen minutes, we were still close to Samos and drenched to the bone.

"Change shift," ordered the boatman, who could assess the difficulty of our situation better than any of us. Meanwhile, I was emptying the water filling the caique with a small tin can. The precious fifteen minutes had gone by, and now our eyes were trained on the cape behind us, where at any time the German patrol boat and her two murderous machine guns would appear.

Luck seemed a little bit on our side as Kusadasi's headland ap-

peared from afar. The waves had subsided, offering less resistance. The boat was lighter, thanks to my efforts, and we moved much faster. Alas, our optimism did not last for long as the much-feared beam of light made its appearance.

"Hold tight, kids. We are almost there," howled the boatman, which gave us courage despite our despair. It seemed as if other men had grabbed the oars. The joints creaked, the rowing boat doubled its speed, and it glided on the waves like a slippery eel. With full-powered engines, the patrol boat was almost upon us. The beam of the searchlight was like a hungry beast looking for prey, and there was no doubt that within a minute we would be caught in it.

We had entered Turkey's territorial waters, and we could discern here and there fires on the coastline that probably belonged to Turkish outposts. What would be the next move of the patrol boat, we all wondered. Would she seize us or simply fire at us? Within seconds, we were caught in the beam, bathed in its full light.

"Row, row! the boatman was shouting, and the oarsmen in a last-minute effort gave wings to the boat. We were no more than a hundred meters away from the coast now, with the torpedo boat two hundred meters away from us, as near as she could get to Turkey's territorial waters.

The Germans were now shouting through a loud hailer, shouting words that we could not understand—nor did we wish to understand them. And then all hell broke loose. A second searchlight lit, and two machine guns raked the sea around us, while their tracers gave the night a festive look. The zip of bullets, some sinking in the water, others beating on the old carcass of our boat, and others spreading death among us, made contact with flesh. One by one, the oars stopped moving as the hands giving them power lay wounded or dead. The boatman was seriously hit, blood gushing from his

mouth and belly. He groaned and cursed before he grabbed two oars. He pulled at them with all the strength left in him, but to no avail. The holes opened by the bullets filled the boat with water, slowly sending her to the bottom of the sea and taking down with her the dead young men. The vessel that meant freedom for these youngsters became their coffin.

In the panic and confusion that followed, the rest of us fell in the water and swam toward the shore, not knowing what our fate would be. After our boat had sunk, the machine guns stopped firing, but the searchlights continued to look for survivors to finish off.

Germans were renowned bullies in such cases, but the Turks were even more so, and they in turn started firing at us from fifty to eighty meters away as we reached the shore, one by one. They made a pretense of defending their neutrality and then sped to arrest us.

How many of us were left? The death toll was tragic: four survivors, including myself, with six dead or wounded who were slowly drowning. Five young boys were lost, full of dreams, and an old boatman was killed like a brave captain, going down with his ship, paying with his blood. His nightly holy mission had been transporting young men to Turkey, men who later constituted the only Greek army in exile.

We spent the night around a makeshift fire trying to get dry and warm up. The weather was not cold, but we were drenched to the bone and exhausted by the long day hike and tragic events of the night. Still, this was not the only reason for my collapse. I could not come to terms with the death of these youths nor grasp at my age the enormity of my first war experience.

Finally, still in this state of mind, I fell asleep, a short sleep full of nightmares. In my dream, I walked into the sea until my head was completely covered by the water. The lack of air did not bother me, and with open eyes I continued to walk in a dim greenish light that shined fantastically in this watery sea world. Soon I approached the site where our boat had sunk next to a large rock. Inside, the bodies

of the five men lay motionless one on top of the other with glaring eyes filled with pain. The boatman was hanging halfway out of his boat.

I was glad to be with them again and felt the need to rearrange their bodies and make them more comfortable as they would stay there forever. When trying to raise them, I saw with terror and disgust hundreds of fish, octopus, and crabs already feasting on their flesh. In my vain efforts to whisk them off, I stumbled on the rock. I woke up with a jerk, realizing that I had been nudged by the butt of a Turkish sergeant's rifle!

It was dawn then, and the other kids were already up trying to make a cup of tea by the dying fire. We were all gloomy, influenced by the night's events, but when you are seventeen you can overcome anything.

By sunrise, in a much better mood, we set off, escorted on foot to a Turkish village called Kusadasi. Our escort was a mustached Horse Guard Turkish officer. He led the procession—but at the time riding a donkey—and he started to sing an *arnane*[3] as we hit the road. Without respite, he finished it off as we entered the village. The time of the march: six hours and thirty minutes.

We remained in Turkey for a short while. The Turks put us up in a hotel named Boudroum Palace, otherwise referred to as a dungeon, and from there some plainclothes Englishmen took us to the train station and on to a freighter wagon labeled "Men thirty, horses eight." It took four days for this wretched train to reach Halepi in Syria after having crossed the whole Asia Minor at the breakneck speed of forty kilometers per hour.

3 *Arnane: long-drawn Turkish love song*

THE DESERT RATS

"Neither is this one ours," shouted Kalothetos as the swish of the bombshell approached and the deadly ironwork passed over our heads. It exploded about two hundred meters farther away, on the outer trenches held by Gurkhas, and killed four or five of them.

Kalothetos had served for six months at the Albanian front, and his hearing worked better than a radar device—which had not been invented at the time. He knew by the pitch of the swish how far the bombshell would drop as surely as he knew that someday the one swishing over his head would bear his name. We never saw Kalothetos again, nor did we bury our dead in Tobruk. We just covered their remains deep in the sand to avoid an outbreak of the typhoid fever that could spread if flies sat in their open wounds.

We had left Athens together with Kalothetos on that last Sunday of May 1941. When we reached Syria via Turkey, all the Greeks who arrived there were gathered by the English, incorporated into one of their battalions, and sent off to Tobruk. Winston Churchill had said that "Tobruk must not fall," and the reason for our presence there was simply for Tobruk not to fall.

For three days and three nights, we travelled from Syria in a convoy of military trucks, crossing Palestine from one end to the other

on our way to Egypt. It was nightfall when we reached Kantara. We found a floating bridge there, and the convoy passed through the Suez Canal to Port Said. An air of prosperity about this town hit us. No blackout here. The first shop windows were coming to life, and as we passed through a main street, I noticed that most of the stores had Greek shop signs. For the ones living here war did not exist or was too far away. They just reaped the benefits: hotels, bars, shops, and cabarets full of Englishmen and men of all races serving His Majesty, the king. And now us, going off to hold Tobruk, a thousand kilometers away from our unfortunate country. Still, as an ancient saying goes: "Any land can be a tomb to eminent men," and we voluntarily chose a seashore tomb in Tobruk, I humorously thought.

Leaving Port Said, we entered the desert that lies between the town and Alexandria. Night had fallen and not much could be seen, but it was obvious that Alexandria was a beautiful and cosmopolitan city. When the last lights had disappeared from our view, we found ourselves again in an infinite, pitch-dark desert. Now all the vehicles turned off their headlights and drove very slowly with only their sidelights on, covered by a small tin lid. We were entering the war zone, and danger from the enemy was imminent.

Two motorcycles of the British military police took up a position at the head of the convoy following a path traced by numerous ruts made by preceding vehicles. The truck engines groaned, driven in second gear but rarely in the third, and the eyes of the tired drivers almost popped out of their sockets. One wrong swerve of the wheel and we could hit a minefield on either side of the road.

Now and then, one could discern a sign nailed to stakes directing drivers to the different units camped in the desert. On one of these, a label read "El Alamein." It was a place still unknown at the time; the decisive battle of the desert war that made this small village famous was fought a year and a half later, in October 1942. We were still in the summer of 1941 and on our way to Tobruk.

During the rest of the night, the convoy passed through Borg el

Arab, Marsa Matrouh, and Sidi Bahrani. At Sidi Bahrani, most of the desert's fiercest battles had been fought. It was daybreak, and we could see quite clearly that once there were houses, people, and shops here—but today…what in heaven's name was this?

Heaps of stones, broken window shutters, and doors, and not a single wall left off more than half a meter high. Everything had been razed to the ground by the canons, aircraft bombs, and tank shells. Right and left could be seen the ruins of burned-out tanks and armored vehicles with surely dead soldiers trapped inside and…helmets, German helmets. English helmets were scattered everywhere! What was this devastation? we wondered in awe. What sort of village was this, only fifty centimeters high? Then came Kalothetos's voice, full of humor: "Come on, there is nothing wrong with it that a few repairs and a coat of paint cannot fix."

This was now the second night spent with thirty men stacked in a jolting truck, the second night of sleeplessness. Exhaustion had taken away our zest for adventure and filled us with dark thoughts as to what was coming next. More and more I could visualize my home and kept wondering what they were doing at this moment in Athens. At dawn, we stopped near an Australian unit for a cup of tea. As we jumped from our trucks, the desert's morning frost hit our faces and brought us to our senses.

There is nothing more beautiful than dawn in the desert. It is the time when the horizon touches the sand, and tiny pink clouds rest on it. I never grew tired of this moment of the day during the year and a half spent in the desert. What I grew tired of, however, was the change of temperature, from five degrees Celsius to forty, and eating corned beef for breakfast, lunch, and dinner. I grew tired of the trenches, the war, the corpses, the blood, and the terrifying swishing of bombshells. Whoever maintains not to have felt fear is either a liar or never went to war.

The hot cup of tea and the warm white bread offered by the Australians revived us. They looked after us well, handing out chocolate bars, cigarettes, and beers. Many of them, only a few months

ago, had fought in Crete. They spoke of the Greek hospitality and the bravery of the Cretans, yet all the while looking at us compassionately. They knew we were off to Tobruk. Having just come from there, after fighting for two months in that hellhole, they were taking a well-earned rest. No one could endure Tobruk for more than sixty days and sixty nights, if of course he ever came out of there alive.

An Australian, having heard me speak English, approached, took a photograph out of his wallet, and said, "This is Matina." He had met Matina in Athens and fallen in love with her. "I will return to Athens after the war and marry her," he continued. I smiled, touched by the naïve faith of this kid. Wait first till you come out of this alive, I thought, and then you can marry. I left him to his daydreaming and finished my cup of tea.

After an hour, we set off for the rest of our journey. The sun was high in the sky by now, and soon our trucks would turn into forty-degree furnaces. Complete silence. No one spoke. Some slumbered, and the rest of us were deep in thought. As we approached our destination, fear had become our only companion. Soon we passed through Soloun, a small deserted native village, and at dusk we arrived at El Adem. From there we would leave the coastline and head southwest, deep into the desert.

I was entrusted with the itinerary by the English sergeant I had befriended since being his interpreter. The English always followed a strictly detailed program, so we arrived at El Adam at dusk and left our trucks, taking our kit bags with us. It was five o'clock, and come what may the English must drink their "five o'clock tea." So, we adopted their habits: tea for the English, tea for the Greeks. Only this cup of tea was drunk under the far-away pounding sounds of cannons and bombers.

Tobruk was no more than ten kilometers away. We would cover this distance on foot so as not to risk being hit by Stuka aircraft sitting inside the trucks. In order not to be detected from the German observation posts, at night we entered Tobruk's stronghold from the protected southeasterly side through a narrow hidden passage cleared

of mines. The whole company of 150 men set off for the ten-kilometer march toward Tobruk, when the British sergeant, whom I still remember well, and whose name was John McNabb, a Scotsman of course, said to me, "You wait here." So I stayed behind; I sat on my kit bag and waited.

A quarter of an hour passed, and the sergeant was nowhere to be seen. Better still, I thought. I will go to El Adem and join some British unit there, eat, sleep, and let the others go to Tobruk. The more I heard the bombardments and Tobruk's artillery, the more I was pleased with this idea. Before I could finish laying out my plan, though, I heard the noise of caterpillars. I froze. Surely the Germans couldn't have come this near. Only when I discerned in the semi-darkness the outline of a Bren Carrier coming in my direction did I relax. I knew the Bren Carriers. Many had been brought over to Greece by the British. They were a small, open-top type of tank, and they were armed with two Bren machine guns. When one stopped in front of me, in the same manner as a Rolls Royce with a chauffeur opening the door for his master, I saw my friend McNabb at the wheel. He told me to "hop in." Never in my wildest dreams could I imagine going to Tobruk in a desert Rolls Royce!

For the first time, I began to realize that my well-remembered mother, Mrs. Polytirni, was far from being wrong when she insisted on bringing home private tutors for me to learn two languages, French and English, for a rainy day. That rainy day had come. Once of these two languages had just saved me from a two-hour night walk in the desert. Furthermore, my regiment had been detected by the flares of a Stuka plane and machine-gunned. Three of my companions were the lucky ones that night. They remained in the sand before having had the chance to gain some glory. I was given the sad news next day in Tobruk when I met up with my regiment.

Meanwhile, the carrier entered the Tobruk stronghold from another passage, because McNabb, who had been in the desert for over eight months, knew his way around very well. This passage, through a dense minefield, was unknown to others. I could see McNabb's eyes

wide open, the wheel in his hands motionless, his lips tight, not a word coming out of his mouth. It took seven to eight minutes to get to the other end, and suddenly we came face to face with ten Tommy guns that were aiming at us.

Two or three of these soldiers belonged to McNabb's unit and recognized him, lowered their guns, and let us through. We were inside Tobruk now.

One would not need an author but rather a film stage director to describe what Tobruk was like and how I felt at the sight of that horrifying scenery of my first so-to-speak night at war. Blackout was complete, but from the glares of the British artillery one could see clearly enough soldiers wearing their helmets. They were armed much like men-of-war crabs, holding machine guns, and five or six hand grenades hung from the pockets of their jackets. Some stood alone, some in groups of five or ten. They ran here and there, either to replace others at the outer trenches or down to the harbor where a small landing craft unloaded the ammunition they had to carry up to the stronghold. Each time a German bomber aircraft made its appearance, they fell to the ground among the rubble or in the improvised trenches to escape the shell fragments. The harbor was also in complete darkness, but the surface of the sea shimmered from the glare of the cannons. And though many bombs were also aimed at the sea, the small landing craft was not hit.

We left the carrier and walked with McNabb to the sector where my people had been detached. Some English soldiers informed him that this was the forty-second air raid of the day. That is to say that in twenty-four hours there were forty-two air raids, which meant one almost every half an hour! One could see several fires here and there caused by incendiary bombs, but no one bothered to extinguish them—there was nothing left to be burned, after all. We proceeded carefully, and now and then fell to the ground for protection. I felt completely lost and very frightened in an unknown world. Bombs were falling.

German guns roaring outside in the desert, the canons in Tobruk returning their fire, screams, fires, soldiers running everywhere,

some carrying the bloody moaning wounded—it was a scene difficult to bear, for anyone. Thousands of men, young kids at that, were part of it, night and day, for weeks and even months. I think I was trembling, and I stuck to McNabb like a child afraid to lose his mother. He was cool-headed, used to this pandemonium.

At one point, he turned around and said to me, "You are brave." I was taken aback! "Others," he said, "go around the bend as soon as they get here and become hysterical."

That was it. I took his words to heart and no longer stuck to him. I walked firmly and calmly, so much so that at the next loud bang, caused by three or four bombs falling a little farther away, I stood up behind a sand mound, a deadly mistake, of course. As I stood erect, I felt a hand grab me from behind, and it threw me face down onto the ground. As soon as the noise from the bombs and the stones and sand subsided, I got up, a little shaken, to thank McNabb, who was standing silently nearby. It was then that I saw an English Captain standing next to him in the semidarkness and looking at me furiously, obviously for my carelessness.

Two years ago, you must remember, I was expelled from college by my English professor, Mr. Peet, who could not accept that a spoiled brat did as he pleased because his parents paid eighty thousand drachmae in yearly school fees. It was a large sum at the time. So I left school and found my peace, and so did he. And now these eyes looking at me grew bigger, full of astonishment. I started to shiver all over. This is impossible, I said to myself.

"You? Here?" he said with an even more baffled expression on his face.

"Yes, sir," I answered humbly.

Here was Peet, cruel Mr. Peet, a captain standing here in front of me! To stumble on him in this hellhole was both unfair and inadmissible. A pure condemnation! Suddenly the look on his face changed. It took on a serene and protective expression as if he were pained for his own child.

He said, "But you are only a young kid," and gave me a friendly pat on the back.

I was no longer the little villain and bad pupil, but a well-behaved seventeen-year-old youngster who had left the comforts of home and put his life on the line to serve in the Allied forces against those who had enslaved his country. Peet was mobilized by the British Government when Greece was occupied, and he had been given the rank of captain because of his profession. He knew of the courage needed to sail from one island to the other, hiding from the Germans until reaching Turkey. That was the reason for this change of heart.

"I had him as a student in Greece," he proudly told McNabb, who was watching us, amazed by what was going on.

I was informed later that Peet was the liaison officer between the unit comprising Greek soldiers and the headquarters of the British commander, General Auchinleck. From this position, he often proved a great help to me. Anyway, we said our good-byes, and, with McNabb, I proceeded to find my battalion, which had been positioned on the north side of the stronghold where most of the German attacks were being directed. You see, the glorious Albanian Epic was still very recent, and the Greek soldier and, in general, the Greek army, was considered then to be the best in the world.

When I arrived at my destination, I found everyone digging… their homes—by this I mean, a pit one meter deep by two meters long, enabling one to lie down. We each pitched our tent, under which, in pairs, we spent the icy cold nights and scorching days during the air raids.

For the first week we did next to nothing, except ride out the bombardments we had grown used to after a while. As soon as the airplanes made their appearance, we jumped in our house-cum-cum-bedroom-cum-whatever else it represented. In there, a bomb could only harm us by a vertical direct hit; otherwise, if it fell even ten meters away, it only covered us with sand and stones. At night, small groups of seven to ten soldiers would go out patrolling around the

minefields. Just routine without heroics!

By the end of that week, though, the situation changed. General Auchinleck, commander of all the desert units, decided to go into battle with armored vehicles and promote his motorized units by opening large passages from the desert to the stronghold, as the only open road of the encircled Tobruk was from the coast. Then, with the support of the liberated Tobruk at the rear, he could proceed to Benghazi.

So, at dawn on Saturday June 29, 1941, an attack was launched outside Sidi Bahrani. After a six-hour formidable battle, the Seventh British Armored Division broke up the famous *Italian Ariete Division*, probably the only Italian unit that fought bravely in the desert front. Unrestrained now, Auchinleck pushed his Seventh Division toward Tobruk. Nevertheless, his tanks were far from their base and supplying them could prove a problem in the event of another clash, something Rommel had thought out better than Auchinleck.

Rommel was waiting for him outside of the southern side of Tobruk with his handpicked Fifteenth Armored Division (Panzer Divisione). The impact was disastrous for the British. Their Matilda-type tanks were faster and more flexible but lighter armed than those of the Germans, and, other than the distance from their base, both men and their machines were exhausted from their fight against Ariete. As a result, Auchinleck was annihilated, and Tobruk was surrounded from all sides by the Germans, leaving the small harbor to serve yet again as the only route of communication.

The "confined" men numbered seventy-five thousand. Of those, most were Australians and New Zealanders, many Indians and Ghurkas, and a few English and Greeks. This was the beginning of the tragic Tobruk siege, which lasted for eight whole months. It is carved in gold letters in the history of war.

Much has been written about the "battle of Tobruk's desperados," about life in the "holes of the desert," about the "Desert Rats." I have no quarrel with historians' detailed descriptions, which are very

near the truth, but I have to wonder about the relation between the man writing based on information and the one who actually lived through 250 frozen, anguished nights, burying his companions for whom often death meant deliverance. Yes, death—but instant death, not lingering, painful, atrocious death from hemorrhage or the putridity of gangrene.

For two days, a young man from Samos Island who had been hit in his gut begged me, "Please finish me off." Eventually, he rested.

The news of the overall siege reached the stronghold at dawn on that Saturday morning. From afar, looking through binoculars, one could still observe a few German tanks coming down south behind the broken Seventh Armored British Division. We were now the defeated of legendary Field Marshal Rommel's African Corps.

The air raids stopped. This was a sign of the uselessness of spending bombs and fuel. They had us all caged in, seventy-five thousand men with few supplies and little hope of replenishing these through a very difficult sea outlet. They surely thought, let them die of thirst or else they will have to surrender or leave by sea. They knew of the English stubbornness, patience, persistence, and self-control. Tobruk must not fall. At once, within twenty-four hours, the orders were issued for planning the defense of the stronghold.

Being a seaside stronghold, Tobruk lay half on the sea, with the other half on the sand. About ten kilometers out was the semicircle, which bordered the sand with its two ends touching the sea. These ten kilometers, no more than a mile deep, became the most deadly and formidable minefield ever in a war zone. Such was the density of the mines that no square centimeter was left that would not blow up. Sometimes we took a stone from the rubble and threw it outside the stronghold, and within seconds could hear the explosion. As if the rest of the explosions were not enough, we caused our own.

The defense plans drawn by the English were ingenious. They opened narrow passages thirty to forty centimeters wide through the minefields, leading up to a square trench of two-by-two meters and

as deep as a man's height. These were the famous "boxes" that were surrounded by barbed wire and sand sacks. Many of these "boxes" were placed in a radius all along the half-moon-shaped stronghold facing the side of the desert. They consisted of the vanguards or fortifications, so to speak; these had to fall first, before the Germans could occupy Tobruk.

The "boxes" were occupied by six soldiers and one noncommissioned officer, enough men to ward off an attack by a group of Germans coming crawling through the minefield. Duty in the "boxes" lasted for two long weeks, before soldiers were able to return to their units. After two weeks, they were back again below ground with the sand up to their necks.

It was quite difficult for a "box" to be captured. Even if a tank passed over it, one could hit it from behind with an antitank weapon. So, the only way to seize it was by a man-to-man fight and, after all, its defenders were slaughtered first. The Germans, being aware of this, would very often send handpicked commandos crawling in the darkness through mines and barbed wires to catch us by surprise. Especially on very dark nights, they had become a real nightmare; we waited with our eyes wide open with anticipation, our ears by now trained to hear even the flight of a fly fifty meters away. We were lucky if keeping guard coincided with a moonlit night. Then our job was easy and…romantic! During the day, our pit covered by the tent to protect us from the sun, which was like a furnace. But after those difficult nights, we slept like logs.

These were the "boxes" of Tobruk and the men living in them were the Desert Rats.

Within a week, the passages had been cleared of mines, and the "boxes" were ready. This was when I had proof of Mr. Peet's magnanimity. He detached me from my unit for quite a long period and used me on translating jobs. He could not keep me there forever, and my turn eventually came; off I went for my fortnight in the "boxes."

My experience there wasn't as tragic as I had imagined. It was my

good luck that the English sergeant heading my group had hearing so acute that he took wind of the Germans from a great distance. He then let them approach as close as thirty meters to our "box," ready to rush us with their bayonets. That point was when they were met by a barrage of our machine guns, aiming at the mines, which exploded and tore them to pieces. The following morning, a whole operation would get underway to collect the remains and bury them in the sand for fear of the black cloud of flies feasting on the pieces of flesh as soon as the sun was high up in the sky, spreading typhoid fever among the men.

The second time around was not similar to the first. Here, the human element, the human error as they say, triumphed. It was past five o'clock in the morning on a less-feared moonlit night.

"I am going off to sleep," said the English sergeant to me. "There should be no problem, but let the others know, and keep your eyes wide open for another half hour until daybreak."

He lay down on his blanket and fell asleep. We all started to chat, drinking coffee from a thermos, reminiscing, telling one another how we got here from Greece, and wondering when we would be able to return to our homes. It was just as we would do if we were sitting in a coffee shop in Athens's main square.

Suddenly, a flash reached the sky and bathed in its light the whole minefield. It was coupled soon after by a blast that broke our eardrums. A type Telerman mine, the largest of its kind, had exploded twenty to twenty-five meters ahead of us.

It was obvious that the Germans had crawled that close and stood up bayonets in hand to attack us when one of them tread on the mine and blew it up. The rest of them saw us in the glare, coffee in hand, and pounced to slaughter us. But twenty-five meters are twenty-five meters, representing twenty seconds, which is time enough for trained soldiers. Of course, there was no time for us to use a machine gun, but our tommy guns went to work like lightning when we saw them standing there. Their bodies begun to fall all

over us, dragging us with them into the pit. We huddled together in the darkness, not knowing who was on top of whom. I didn't know whom I clasped in my arms, if it was a German or one of our own, if he was dead or alive, if the blood I touched was mine, if, if…

The firing had stopped, and the Germans surely must all have died. We freed ourselves and lit a hurricane lamp to see what was going on. We finished off any Germans we thought were still alive with a bullet in their heads and threw them outside the pit. On the other side of the "box" there was a German who would not move from on top of someone under him. This someone was Vangelis, who worked at the Piraeus harbor slaughterhouses. But what had happened here?

Vangelis was unable to use his Tommy gun in time, but he always carried a huge knife strapped to his belt, the type of knife he slaughtered beef with, and when he saw the German, he drew it and stabbed him. As the German fell, his bayonet pierced Vangelis's gut and came out on the other side. When we pulled the German from on top of him, he was on his last gasp and his wonderstruck open eyes seemed to say, "How could I have put my foot in it?"

Meanwhile, our English sergeant had jumped up and furiously—quite rightly so—turned to me to give me a good dressing down, as I understood his language, for having carelessly allowed the Germans to reach the "box."

"You had two of them on top of you and all you did was drink your coffee," he said.

That was not exactly what had happened. I had anticipated one of them, and I am sure I killed him. The other must have been had by the English sergeant right behind me, still holding a gun in his hand. I owed him my life.

In the morning, we buried Vangelis out there, outside our "box," and when a soldier came carrying a wooden cross and some paint to write his name on it, I grabbed the paintbrush and wrote underneath, "The beef got you." By that I did not mean the Germans but the beef he slaughtered in Piraeus…taking their revenge.

Of the eight months that the Tobruk siege lasted, I spent three in the "boxes." It is difficult to describe how hard-hearted a person can become, once used to filth, flies, blood, dismembered corpses, being in a furnace during the day, being frightened all night, and having despair turn into a death wish—and, as I said, this death should be quick, not a lingering one. I witnessed such savagery during these months that I could hardly recognize myself. I had turned into an indifferent, cold-blooded beast. I buried my dearest companions without shedding a tear; instead, I felt grateful and pleased to be alive.

Once more, the air raids came in waves of twenty to thirty a day, once the Germans realized that we did not give in and that Tobruk was still holding on, preventing Rommel's plan to launch a general offensive that would enable him to enter Egypt and from there continue on to the Arabian oil wells. With Tobruk at his rear, he could not risk it.

So, this was our life. There were moments when we became hysterical. When will it all end? Let the Germans take all of us prisoners, let us die, anything is better than this! Living for eight long months in this hellhole seemed to last forever. But man has great powers of endurance…and one morning, by the end of these eight months, after a fierce battle, the heroic New Zealand Second Division under General Freyberg, the famous warrior of Crete, and the shock forces of Alexander's Indian Division came to end the siege and isolation. It seemed as if tombs had been opened and the dead resurrected.

Churchill had asked the sacrifice of seventy-five thousand men to hold Tobruk and win the desert war. This sacrifice cost thirty-five thousand wounded, several thousand dead and twenty-five thousand living dead! All of them were young men, twenty to twenty-five years old, and they were buried in an immense desert. Thousands of crosses stuck in Tobruk's sand, witnesses of the sacrifice that turned around the outcome of the war. Among them were a few Greeks of the 1940 generation, who added a small stone in the road to victory against Rommel's formidable army.

After the war, the men of the so-called Desert Rat unit founded

a club in London that the English hold in great respect. They always regard the survivors with the highest admiration and esteem.

Characteristically, when in 1968 Queen Elizabeth awarded the Beatles an OBE for the foreign currency influx due to their records, the Desert Rats were advised by their committee to return the equivalent decorations received by King George, father to the present Queen, for their heroic eight months in Tobruk. The survivors, as well as the families of the dead, did so as a sign of protest. This great sacrifice of young lives could not compare with the foreign currency imported in England by some longhaired singers.

Many of the Rats were still alive at the time, and the Queen sent an apologetic letter to each of the Tobruk veterans, as well as the families of the dead. The letter read, "Your sacrifice brought victory to England, but Great Britain must win the economic peacetime war." With the letter, she returned the decorations.

Small war stories have great moral importance.

When someone asked me, "If your house caught fire, which most valuable item would you try and save?" Without a second thought, I answered, "My war decorations because they represent the most significant part of my life."

Within two days, we handed over our positions to the New Zealanders, and the living ghosts of Tobruk took the road for Cairo or Alexandria. Most British units went to Cairo, while the Greek ones went to Alexandria as the First Greek Brigade was being established there. It consisted of Greeks fleeing their country or others coming from elsewhere to join the ranks, as well as the ones living in Egypt mobilized by

the Greek government in exile, with its headquarters in Cairo.

On our departure, before getting in the trucks transporting us to our destination, I turned around and cast a last glance at Tobruk with very mixed feelings. I was overwhelmed with joy for leaving behind me an open grave where I had lived the worst moments of my life. Yet, I felt an uncalled-for nostalgia for a place I had grown fond of. How could I possibly feel affection for a place where I had spent 250 days and nights in fear and sheer agony? How true was the Greek saying that the soul of a man is like an abyss? I felt I had to give thanks to God or to Tobruk for getting me out of there alive and for not sharing the misfortune of the dead soldiers left buried in the sand.

My thoughts were interrupted by a hand pulling me from behind. It was the same hand that pulled me to safety on my first night in Tobruk. It was that of my professor Mr. Peet.

"Come ride with me to Alexandria in my jeep," he said.

Two joys in one day! This would save me two days and two nights of jolting and discomfort. The jeep was put at the disposal of Mr. Peet by the New Zealanders, and his first thought was for me!

As we drove along, he suddenly said, "You have survived. You know the meaning of this? If you have survived Tobruk, you will not die in this war in as many battles as you may take part."

I remembered these words more than once, and whenever I had a narrow escape would say to myself: Peet was right!

THE MAN I LOVE

Night had fallen by the time we had arrived in Alexandria after a fifteen-hour drive by jeep in the desert. I had never been to Alexandria before but many of my friends from Egypt came every summer to Kifissia,[4] where my home was, and I knew many young navy officers, who, when still cadets, also came often enough to Kifissia. Having been informed by a Navy officer I met in Syria that all Greek Navy officers frequented or resided at the Metropole Hotel, when Peet asked me where I intended to stay, I answered, "At the Metropole," leaving him speechless. Peet knew Alexandria pretty well, having served there for some time.

"It is for officers only, and it's very expensive."

"Sir, I haven't come out of a tomb just to get into another one because it will be cheaper," I answered.

This phrase was very representative of my character and the mentality of a man like me who could live in a grave on the brink of death one day and the next live like a prince without a care in the world. This is what I have been like all my life. Besides, the last thing I could think of at that precise moment was how to save money…

4 A suburb north of Athens, the equivalent of Hampstead

This reminded me of the remarks made back home by my father and got on my nerves. Here I was living on borrowed time, a leftover, so to speak, from a massacre, and I was expected to consider the cost of a hotel!

Peet drove me to Saad Zhagloul Street and deposited me outside the Metropole.

"Good-bye. See you soon," he said, as if bringing me home from a party. This was wartime, and too many emotional scenes were quite unnecessary; otherwise, one would be permanently upset by endless good-byes.

My appearance was terrible. Though we had changed into clean uniforms before leaving Tobruk, I was unshaven, shabby looking and overly tanned, scorched by the desert sun. At the hotel entrance stood a huge Arab in a red uniform. He looked down at me with disdain, and then peered at my shoulder to look for a star.

Not seeing one there, he said, "Officers only."

I took out of my pocket a bundle of money given to us by the British before leaving Tobruk and handed him a pound. In Egypt, a tip amounted to two piasters (one hundred piasters to a pound), and one pound was the equivalent of a month's salary for the Arab. I had no idea of the value of that money. The next day I was due to go to the Military Police headquarters with a paper issued to us and get double that amount from the cashier of His Majesty, the King of England. All in all, I was owed nine salaries plus extra benefits and bonuses. We had put our lives on the line; at the very least, we should get paid for it!

In the meantime, the Arab porter almost fainted at the sight of the pound. He took off his fez, broke his back dropping low bows, carried my bag, and I thus arrived at the front desk.

Two or three of the employees there gave me another look while repeating, "For officers only." At that moment, a rather short, rather bald gentleman appeared, intensely searching my eyes for recogni-

tion. I shared the same feeling.

"You are...?" he said. At the sound of my name, he smiled. "John Tamvakakis," he introduced himself, and at once the summers in Kifissia came to my mind.

He was the owner of the Metropole and had turned his hotel into a naval transit point, as he knew many young officers from Greece, including captains and admirals. This place felt more like the Greek Admiralty than a hotel.

"Have you just arrived from Greece?" he went on asking.

"What are you talking about...? I have come from Tobruk," I answered.

At the word Tobruk, his eyes goggled, and he went speechless.

After a while, he repeated in a loud voice that was heard down the hallway, "From Tobruk?"

The man couldn't believe his ears. Everyone knew from the newspapers and radio what being in Tobruk meant and had heard that the eight-month siege had been lifted only two days ago. And now, here in front of him stood someone who had just come from there! No wonder he had turned into a stone statue.

In the meantime, his loud exclamations had gathered around us the navy men from down the hallway and from the bar, all of whom wished to have a look at the man from Tobruk. Some faces were familiar. Finally, John T. gave me the key to a room and said, "Go upstairs, have a bath and a shave, and then we will see what we can do with you."

John T. is no longer with us, but he was an exceptional man, a true patriot who welcomed to his hotel the whole of the fighting Navy, whether these were friends or newcomers. Some of them paid when they had the money, others went broke playing cards or celebrating. Yet John T. always offered his hospitality and affection to everyone. We later became great friends. Wherever he is now, if there

are books in paradise, let him read this one to remind him of Alexandria, the war, our brawls, and our friendship.

I got into a hot bath and soaked in its perfumed water. But when I pulled the plug to let the water out, the tub practically clogged up from the filth and the sand. Where I came from, all we had was a flask of water to last for two days just to make sure our lips did not swell from thirst. If we were lucky enough to steal a few minutes away and have a dip in the sea at night that was what having a bath meant, and it ensured cleanliness for eight long months!

I shaved and was about to dress when the telephone in my room rung. It was John T.

"Have you got any clothes?" he inquired.

"What sort of clothes are you talking about? I have my clean uniform."

"A soldiers' uniform? That is out of the question. There are only officers here, and you will not be able to join us. Wait for me; I'm coming up."

He came up to my room with Noni Steryiakis, an acting sublieutenant friend from Athens, and they began to discuss whose clothes—of those now out on patrol—would fit me. They decided on Marios Horsch's civilian clothes. Of course, as John T. had skeleton keys to all the rooms, all three of us went along—I was in my bathrobe—to the room that Horsch was sharing with Loundras, who was also out on patrol in his submarine. I tried on a casual checked jacket and a pair of gray trousers that fit me. They must have been Horsch's, though Loundras to this day insists that the jacket was his. Anyway, I took the clothes. John T. gave me a shirt and tie, and upon getting all dressed up and looking very handsome, I went down to the bar.

Had I entered any bar in Athens or Kifissia I would have come across fewer acquaintances than here. Other than the young naval officers, there were some girls who had escaped from Greece and did voluntary work as nurses at the Alexandria Kotsikio hospital.

Oddly, though they all surrounded me, falling all over me and asking what I would drink—one ordering beer, the next one sandwiches—at the same time, they stared at me and whispered to one another as if a strange phenomenon stood in their midst, a sort of extraterrestrial of our days. The newspapers and radio had done a good job of informing the public that there were no survivors in Tobruk, so they fired so many questions at me that I had to stop them.

"Slowly, guys. Of course there are survivors, two and a half thousand of us, and I was one of the first ones to get out the day before yesterday."

Someone asked, "How many were killed?"

When I answered, "Thirty-five thousand wounded and several thousand dead," everyone froze.

The newspapers hadn't mentioned any numbers. They froze because they had fought at sea on surface boats or submarines for only twenty days and were in Alexandria for the last ten. Each time they left on a dangerous mission, they knew that they may or may not return as many of the Queen Olga, Adrias, Katsonis, and Triton warships didn't do so. The meaning of war and death was familiar to them, but so many dead in one confrontation was too much to fathom.

In the meantime, with so many "drink ups," "bottoms ups," and "chin-chins," we got really stinking drunk. At some point I shut my eyes, reminiscing about where I was only two days ago and taking stock of where I was today. Not even in my wildest dreams could I have imagined all this luxury and wellbeing when I was out there.

I opened my eyes to erase the black thoughts and horrible images. Life is wonderful, I thought, and I must live it to the full.

"I am hungry," I said, and I suddenly realized that one's stomach is not just there to take in drink but also some food.

At that moment, the famous "Rabbit" appeared, looking fresh and dressed to the hilt. Rabbit was a notorious Athenian prewar and

postwar character. The older generation will remember him well, but I will give you a description of his virtues and merits. To begin with, he was very astute, with a fast brain and a quick sense of humor. He never did any kind of work, but he was well established in the Alexandria and Cairo casino network and even more so in the racecourse one.

Sometimes he was loaded with money; at other times, he was penniless. Mostly, he was without a penny—dry as he used to say—but tonight he was far from dry, for as soon as he heard me say the word "hungry," his reaction was immediate: "Let's go to Santa Lucia."

In fact, he used that magic word with the panache and the debonair expression of a rich man about to invite everybody present. We all stopped to stare at him—even with his arms raised above his head, he was no more than a meter tall—wondering where he had found so much cash. He lifted the folded newspaper in his hand and smacked it with his other hand, saying with a roguish expression on his face, "For God's sake, can't you see the bloodshed?"

The headlines read: SLAUGHTER AT THE RACECOURSE.

"Ivan brought in big money." Ivan was the horse he had put his money on. So, Rabbit was loaded and hosting at Santa Lucia (one of the smartest restaurants in Alexandria and where the navy officers usually went—if they were in the money).

I really and truly lived again. At Santa Lucia, I ate my bon fillet with a knife and fork, on a dazzling white tablecloth, with Arab waiters serving wine and wearing white-starched galabiehs and white gloves. No more holding a tin in one hand as I had for eight long months, flicking the flies with the other hand while hurriedly pushing some corned beef in my mouth.

Life was wonderful after all, and the wine had done a great job.

Yet, while eating my thick, juicy steak, I caught myself several times furtively looking around for flies. Rabbit paid the bill as promised, and we left the restaurant. Sleep was out of the question. Rabbit had already worked out in his mind that after so many months in the

desert I must be loaded.

He said to me, "In Tobruk, one cannot spend money, right? Let us go to the Carlton."

The Carlton was another hotel with a fantastic nightclub in the basement. The officers left us to it. Some were leaving at the crack of dawn and went directly to their ships, and the others headed back to the Metropole to get some sleep.

Rabbit entered the nightclub first and found the owner. God only knows what he whispered in his ear; we were shown to the best table near the dance floor. A group of dancers named the Zanofski Trio were performing. I remembered them well, as in every nightclub I went to, whether in Alexandria, Cairo, or Port Said, I found them dancing there. The Trio consisted of two girls and a man, Zanofski.

"Don't look at them," said Rabbit. "They are not worth it. Wait and see."

I patiently waited for the worthy one and worth it she was! When the warmly applauded Trio retired a sensational pianist named Johnny Haysmith made his entrance, greeted Rabbit with a nod—Rabbit being a trade name—sat at the piano, and began to play. My ears hadn't heard the sound of music in months. I was in seventh heaven.

As the pianist went into the second song, "The Man I Love," a gorgeous creature whose beauty left me speechless appeared from behind the curtain. She walked nonchalantly to the grand piano, leaned on it, and began to sing, "Someday he'll come along, the man I love…"

She was tall, with blond hair and blue eyes. Her long white gown with a deep neckline and an open back revealed her fantastic figure. Two strings of white pearls were around her neck. She had all of this, plus a warm voice that made me fall in love with her at first sight.

As soon as I recovered from the shock of the moment, I uttered, "Rabbit, what kind of creature is this?"

"Let it be," he answered. "She doesn't go for it."

The others are not worth it, this one doesn't go for it, what am I supposed to do, I thought, take the Arab with the galabieh? Rabbit shook his head, but I couldn't take my eyes off her. As soon as she finished her song, the pianist introduced her. Her name was Yuki Russel and, as Rabbit informed me, she was an American Jew. Now the question of why, instead of being in the war-free United States, she chose to be two hundred kilometers away from Rommel was worth getting into.

Our table was at the very front near the dance floor, and together with two or three others like it was the best and always the center of attention regarding any noting of who's who. But mostly the performers had an eye on that, and so Yuki cast a glance in our direction. It was obvious from the way she looked at him that she had seen "trademark Rabbit" before.

I was of two minds as to whether this was a good or bad sign. Still, I doubt I went up in her esteem for the company I kept. Before she ended her program, she cast another glance, and when she left the floor, I said, "Rabbit, go inside and invite her over for a glass of champagne. I don't want to send the waiter and risk offending her."

"I am not going. She is not a club hostess."

"Go, damn you, and tell her I've come from Tobruk."

"She will not give a shit," said Rabbit.

"Aren't you ashamed that poor old me was fighting while you were having a good time?"

He always had a ready answer. "Don't blame me if you were taken for a fool!"

"Rabbit," I said, this time in anger, "tomorrow I will go to the Military Police headquarters and have you arrested for not having reported even once to your unit since your arrival here."

At the mention of the words *Military Police*, he gave in.

"I'm going, but do not expect her to come."

I drank two whiskies in one gulp from sheer agony and waited for his return. Rabbit came up trumps, and he did bring her to our table. I got up to welcome her and when she gave me her hand I almost flipped, blood rushing to my head. Really and truly she was a divine creature. She sat next to me, and on the other side sat Rabbit, whose presence now annoyed me.

"I came when *le Lapin*[5] mentioned you were in Tobruk for eight months and today was your first night away from the war. I would be a monster not to come."

It seemed *le Lapin* had worked on her feelings pretty well and had moved her. Apparently he befriended the pianist and that explained how they knew each other but how his mind worked pretending he didn't know her was difficult to explain.

We got talking about the war, of course—what else?—about Tobruk, the minefields, the dark nights. She kept looking at me in silence, thirsty to hear and learn all about it. I was cashing in on Tobruk, realizing that I was gaining her through my misfortunes. She did not order champagne, just drank one whisky after another, all the time listening to me and looking deep into my eyes.

I cannot remember or recollect for how many hours this went on, but at some point I knew that the foreplay had done its work. It was time to get into the next stage and see what would happen from then on. So when the orchestra began to play "Again," at the line "it never happened again," I got up saying, "Come on, Yuki, let's dance. Enough with the war." And as the singer was at that moment repeating the words "it never happened again," Yuki, looking straight at me, said, "Are you sure?"

That's it; I thought to myself, the time for the warrior's repose has arrived. When we returned to our table, I said I was very tired and must catch some sleep without adding any of the usual when

5 *French for "the rabbit"*

will I see you again, or may I take you home, which can put a woman on her guard by revealing exactly what you wanted her for.

She seemed surprised, not that I expected her to have already fallen for me but by my behavior, which was different from than that of the usual male clientele of the nightclubs.

Walking to my hotel, which was just across from the Carlton, in the warm Alexandria night, Yuki was constantly in my dizzy head. I woke up the following evening, not surprisingly, as I had not slept for the last forty-eight hours. I went to the movies with my friend Mourginakis, an officer in the Royal Navy whom I knew from Kifissia, and we saw *Down Argentina Way* with Carmen Miranda. I decided not to go and see Yuki that night so she wouldn't think I was chasing after her, and my friend, a professor in matters of the heart, agreed with me. But I went the following night. When I walked in she was singing "The Man I Love."

The waiter showed me to the same table, having realized he had to deal with a good future client, and this is what happened next.

Yuki took the microphone in her hand, came to my table, and sang "The Man I Love" just for me, the emphasis on each word and all it implied. The syrup had set!

"Today, no war talk," I told her. "Today we will—"

She didn't seem to listen and interrupted me. "Why did you not come yesterday?"

"So that I would miss you more," I answered, enjoying this dialogue full of innuendoes.

She smiled, sat next to me, and ordered a whisky. Tonight, she was wearing a long black dress that enhanced her blond hair and blue eyes, giving them a special glow, and I knew then exactly what was happening to me…

We spent the first fortnight of my leave in heavenly bliss. During the day, we went sightseeing—among other places we visited was

King Farouk's summer palace in Montanza—but mostly we spent our mornings swimming at the Sidi Bishr beach. At night, after she finished her floorshow, we went to other nightclubs, dancing and drinking.

One evening, while dancing at the Excelsior Club, some wretched Italian pilot chose to make his rounds at a safety height, as per usual, of several thousand meters over Alexandria. The air-raid alert sounded, and at that moment I broke out in laughter at the sight of the panic-stricken people who were obviously completely out of touch with the war. I was left alone on the dance floor with the shivering Yuki in my arms. I was really having fun with the situation and tried to reassure her that even if a bomb fell on the building at the very most it would damage the two top floors out of the eight and that for it to reach the basement where we happened to be it would take at least the direct hit of another ten bombs. The following day's newspapers headlines read: Alexandria Endangered by Enemy Planes!

At the end of the fortnight, Yuki's contract with the Carlton came to an end. The next week, she would start singing at the Heliopolis Palace Hotel nightclub. Heliopolis was the most aristocratic suburb five kilometers out of Cairo and practically all of it belonged to French Baron Empien. It had been built by his father at the end of the last century, based on the plans of French architects and in the grand style of that era. The hotel itself was similar to the Cote d' Azur's Negresco and the Carlton Hotels.

I moved to Cairo with Yuki and, as her contract included hotel accommodation at the Heliopolis Palace, I moved in with her to save on my hotel bills. More bliss here in Cairo: The Pyramids, the Sphinx, and the rest of the sights, which thanks to Yuki's presence took on an even more special meaning.

One evening, Yuki had an all-night rehearsal due to a program change, and so as not to stay alone, I went to Cairo for a change of scenery. Too much of a "married life" risked tiring me.

So I took the small electric train connecting Heliopolis to Cai-

ro and after fifteen minutes arrived at the Kasr-el-Nil Square. From there, I walked for five minutes to the cosmopolitan Shepheard's Hotel, where I was sure to find acquaintances and see familiar faces.

It was nine o'clock in the evening, and the bar was blurred with smoke, heroes, spies, traitors, deserters, usurpers, princes, legionaries, and warriors. All the little men were in colored uniforms, moving around with glass in hand, making new acquaintances and telling one another of true or make-believe heroics. Some were trying to sell lots of car tires stolen from the British Army to international crooks. Others were buying gold pounds from rich Jews who had fled Europe to escape from the Nazis. The women were also selling their goods of hashish and opium, and some were selling sex. The whole atmosphere reminded one of the Humphrey Bogart film *Casablanca*, which happened to be on at the nearby movie house.

I took a glass of whisky from the bar and was looking for a quiet table to have my drink when I heard a familiar voice. I turned around and saw a couple sitting at a table—a handsome navy officer and next to him a gorgeous young girl with long red hair and slit eyes. It was my friend Mourginakis, the one I had met in Alexandria, a daredevil on board his ship as well as in the matters of the heart. With him was Niki Demis, who was one of the most beautiful girls of her time and had just arrived from Greece. They made a handsome couple and seemed very much in love, a strange contrast in this mysterious colorful chaos of the Shepheard's bar.

"Sit down," he said, "and fill me in on the outcome with Yuki after I last saw you in Alexandria."

"All is well," I answered. "Don't worry about me. I am leading a perfect married life, living with her at the Heliopolis Palace while she sings downstairs at the nightclub."

"Well done. I'm proud of you. She sings, and you sleep in her room. Now, let's drink to your health…And, by the way, how long are you on leave for?"

"I have no idea," I answered, and he advised me to go and pay a

visit to the Military Police headquarters the following day to find out.

"Go and find them before they find you."

We went on talking and laughing. Even the saddest topics were met with laughter. It was out of a spontaneous joy for being alive when thousands every day were killed or died in the desert, at sea, or in the air—the same wellbeing one feels when in a warm firelit room while it is stormy and freezing outside.

My friend lifted the bottle, filled my glass, and said, "Drink, drink up. For you are living on borrowed time. You are a leftover from where you came from."

I had heard this before. The following day, Niki would be on her own; my friend was leaving on patrol with his other girlfriend named Niki.[6] We said our good-byes with a squeeze of our hands and a pang in our hearts. What could I say to him? Hope to see you soon, if you don't get killed? So, we simply and silently went our separate ways.

I walked leisurely in the warm Cairo night up to the Kars-el-Nil station to take the small train back to Heliopolis. A couple of drunk English soldiers stopped me, asking for a shilling to buy one more beer. Who knows what these poor devils had been through and needed to drown in beer in order to forget? On the train, leaving behind Cairo's last districts, we entered the desert. Heliopolis was built on the sand. Suddenly, shivers ran up and down my spine, and all the memories of Tobruk, the boxes, the dead came rushing to my mind. Going up to the hotel room, I was seized by a bad premonition.

Yuki was already asleep. I got into bed and slept in her arms as if this was the last night with her, scared of losing her.

I woke up at eleven o'clock the next morning in a lousy mood, having been badly affected by my journey in the desert at dawn. I also couldn't get out of my mind the words of my friend Mourginakis: "Go and find out." A month had gone by since I had left Tobruk,

6 *Niki (Victory), a destroyer torpedo boat*

and the war hadn't come to an end—quite the opposite. Rommel, under pressure from Hitler, was preparing a major offensive building up new forces to enable him at any cost to advance toward Egypt and across the Suez Canal so as to reach the Middle East oil wells.

So, I put on the uniform I had not worn for over a month and got ready to present myself at the Military Police headquarters to find out how much of my leave I had left. I kissed Yuki, who was still asleep. She opened her eyes, saw me in uniform—she had never seen me in it before—and jumped up, shouting hysterically, "Where are you going?"

I explained, trying to calm her down, but she was kissing me over and over again, not believing a word I was saying. Only when I told her I was going to get my suit to be pressed did she relax. By my suit I meant, of course, the jacket that probably belonged to Loundras and Horsch's pair of trousers.

When I arrived in Cairo, I took a cab to the posh part of town named Ghezirah, where the premises of the Greek government and the War Office were situated. I inquired after the officer on duty, and when I entered his office this is what happened.

I saluted, he returned my salute, and, as soon as he saw me wearing the Desert Rat's British decoration, he took on a look of admiration. But as soon as I showed him the British leave issued to us on our departure from Tobruk, his face clouded over, and he got rather angry.

"Do you know you are in the Greek army and not the British one?"

"Of course I know."

"So why did you not present yourself at the Alexandria Military Police headquarters to verify your permit and take a leave for specific days from the Greek army?" He continued, "Are you aware that you have been unjustifiably absent from your unit for thirty-two days in time of war? Do you know that I am under the obligation to arrest you?"

Now it was my turn to get a little angry, as angry as a soldier

could get at a superior officer.

"Do you know where I have come from, Captain, sir?"

Here is where I made my deadly mistake given the fact that "Captain, sir" suffered from our national ailment: an inferiority complex. I had wounded his pride—and the three stars on his shoulders he gave a shine to every morning.

"You are not the only one that went to war. We have our own war, too," he retorted.

What could I tell this man who was fighting his own war from the most sought-after district of Cairo, from his bureau with a view of the Nile!

Of course, I did not keep my big mouth shut, I said, "No doubt the enemy is everywhere."

Captain Sir caught the irony of my words and became livid.

"Sergeant!" he shouted, and his desk in Cairo's most sought-after neighborhood shook.

In came a very tall, mustached sergeant, an ex-policeman and ex-gendarmerie hero of the Cairo Military Police headquarters. This hero arrested me by order of "Captain Sir" and escorted me handcuffed to Palestine and to the First Greek Brigade, to take part in the desert battle against Rommel. Normally, I would have been issued with marching papers and presented myself to the brigade, but already the handcuffs had been put on and the escort ordered by "Captain Sir."

When leaving his office, I saluted him and said, "I don't wear my medals as you do, Captain, sir, on my shoulders, but on my chest."

During the twenty-four-hour trip from Cairo to Palestine, where this Tobruk hero was escorted in chains, I could think of nothing else but poor Yuki, who waited for me with the pressed suit at the ready. I would never show up. She would wait alone in the room until it was her turn to sing, and I wondered how she could possibly sing

"The Man I Love" tonight. Surely many unfair thoughts concerning my person must have been crossing her mind, but the last thing she could ever imagine was what was really happening to me.

All the adversities in my life have been caused by cowards, idiots, and people ridden with inferiority complexes. This "Captain Sir" with a smokeless gun could not hide his envy for someone who had really been in action and was now mocking him with contempt. Truly, I did feel contempt for this little man comfortably sitting at his desk, who had supposedly fled Greece to fight for his country. And there were quite a few such little men in the Middle East, playing at being heroes on their return to Greece.

Thanks to such a man I was never able to say good-bye to Yuki, to say the farewell I should have as a man who had fallen in love with her, loved her, and lived the most wonderful month of his early youth with her. All that remained was a sweet memory of the war years.

SOLDIERS ONLY FIGHT

At the Palestine camp, the behavior of the officers toward me was entirely different. I presented myself to a colonel named Meli, a very special person, well read and just. His look fell simultaneously on the handcuffs and on my decorations, one incompatible with the other: the hero and the traitor, for only traitors were led handcuffed to the firing squad.

At once, he turned to the sergeant and, with a stem look on his face, said, "Take off his handcuffs." Then, turning to me, "Tell me in your own words what you have done."

I told him while rubbing my wrists, which still throbbed from the grip of the handcuffs, that when leaving Tobruk the English issued me with a written document for an indefinite leave. After one month, I presented myself to the Cairo Military Police headquarters. I showed him the said document.

He obviously knew how to read English and, turning to the sergeant, he asked, "What are the handcuffs for?"

"He is a deserter, Colonel, sir," said the gendarme.

And then, all hell broke loose. This calm gentle-natured man worked up a rage, "You, good for nothing, have parked yourself in

an armchair. You stroll around Cairo since your arrival from Greece and get paid for it on top of everything else, and you dare in my presence call this man a deserter? My captain, Colonel, sir—who is your Captain, you scallywag?"

"George Petridis, Artillery Captain, sir," said the now shaking gendarme.

"Your captain must have many guns under his orders in Cairo," he said. And addressing him furiously, "Get lost—get out of my sight."

When the door closed, he gave a sigh of relief as if a weight had been lifted from his chest.

I was standing there silent, still rubbing my wrists, when a soldier entered the room with a large file full of documents.

"The English messenger brought these from the New Zealand Command headquarters."

"Who will translate these?" said the colonel, talking to himself. The messenger did not speak. It was then that I broke the silence.

"With your permission, sir, I can undertake these translations."

He showed surprise. "You know enough English to translate these circulars?"

"I have finished the Anargyrios College, Colonel."

He completely flipped. What sort of chap is this, he must have thought, who found his way to Tobruk, who was brought to me as a deserter and now he tells me that he graduated from one of the best schools in Greece?

"All right, son, go and find Sergeant Perris at the Artillery Company to settle you in, and in the morning after roll call, report to me, sit at the desk next door, and begin translating."

On my way to the Artillery Command, I pondered his words. He called me his son, but had I really been his son would he send me

to the Artillery Command? That brigade was getting ready to leave for the desert, and I had just been detached there. I knew exactly what that Command meant: Always first on the front line, and I had won the first prize once more! Nothing lost, nothing gained! Still I didn't care much one way or the other. I felt like a mountain getting used to the snow.

I found Sergeant Petris, whom I knew well as he was in my group that fled Greece—an interesting type, full of humor—and he made arrangements for me to sleep in his tent with him.

The next day, I went to the colonel's office. He gave me the circulars, and I went to work. It was nothing special, ten circulars of one page each. I finished at noon and the colonel once more flipped by the speed and the quality of my translation.

"You are well learned."

I did not answer, just smiled. It was quite unnecessary to tell the man I had been expelled from almost every school! Let it be. Let him think I was a good kid and pupil.

The following day he asked for me again. He kept me for one hour, this time to talk about the war. He wanted to know everything about Tobruk, the defenses, the English war tactics in the desert, etc. For what could the poor man know about the desert? He had fought on the Albanian mountains, and I suppose the only sand he ever saw was at the seaside where he swam with his lady wife. Yet they were preparing us for desert warfare. If all the officers knew as much about it as my colonel did, we would all be doomed…God help us!

"I will remove you from the artillery," he said.

"Thank God," I thought.

He continued, "And will appoint you to train mine sweepers." Now what could I say—I had just thanked God for nothing. When

you get involved with mines, you don't need to die in battle. You get killed at any time, on any day, including Sundays and holidays.

So, I began to train mine sweepers. I penned in a quarter of an acre of Palestine sand and turned it into a minefield with real mines, but without the detonators until at least they learned all about them. I taught them what shapes to look for on the surface of the sand where a mine lays, how to tread on someone else's footprints, and how, if the person preceding you is blown up but is still alive, you do not move an inch but try to catch an end. Pull, slowly, you and him out of the minefield, treading on the same footprints. It all sounds very simple, but when there are mines under you, it's a completely different story.

The Colonel promoted me to the rank of Corporal "so that I could command respect," and life in the minefield continued. As the training period of the first group was coming to an end, a soldier from Samos island who thought he knew it all made a false move, trod on a mine, and lost one leg.

"Stay lame to learn your lesson. At least the war is over for you minus one leg," said a fellow islander to him.

Two or three months went by while I trained the entire Brigade, but no one could tell for sure that this unit was ready to fight in a tough desert war. One morning, though, events took a new turn, throwing all the planning and logic to the winds.

During a general offensive Rommel seized Tobruk—after we had made so many sacrifices to hold it for eight months—and proceeded undisturbed on a front many kilometers long from the shore, deep into the desert, even deeper than Bir Hakim, the famous stronghold of de Gaulle's "Free French." Rommel swept through it all, and nothing seemed to be able to stop him. General Auchinleck panicked and could not regroup in order to contain this torrential attack. One by one, the British strongholds collapsed. Next came Bardia, Sojourn, Sidi Bahrani, Marsah Matrouh, and lastly Fouka. In Alexandria a general scurry prevailed, and all the foreign services left for Suez and

the Sudan. Our own Admiralty moved to Suez. SS *Corithia*, which served as a base for submarines, left with them for Beirut.

The well-to-do Greeks shut up their houses, taking all their valuables, and also left for Suez. The English banks transferred their cash, gold, and records to Sudan, even as far as Nairobi. Only the two hundred thousand Italian civilians celebrated by ironing their flags to welcome into Alexandria the Italian and German armies.

Rommel was advancing unrestrained, and the fact that he did not enter Alexandria was not due to some military resistance but to two imponderable factors. Firstly, fifty miles off Alexandria in the village of El Alamein, a place later to gain great fame, is a narrow strait of twenty kilometers from the shore up to the Qattara Depression. This depression covers an area of about four hundred kilometers long by a hundred kilometers wide and consists of very thin, very soft moving sand and anything treading on it, be it machinery or human, simply sinks. The Qattara Depression is a natural defense shield for Egypt, which starts from Fayoum outside Cairo and ends in El Alamein, leaving only a twenty kilometer wide passage from the shore free of this quicksand. So the German forces that were deployed on a wide front of many kilometers (and where Rommel, the Desert Fox, was preparing his diversionary and surprise attacks) had to squeeze into this narrow passage. The second and most important factor that grounded Rommel in El Alamein was fuel shortage.

Yes, all of Rommel's mechanized units were pinned down forty-five kilometers off Alexandria, due to fuel shortage. As was later revealed, a convoy of eight to ten oil tankers coming from Greece was intercepted by the British War Office, thanks to information given by Greeks collaborating with English spies. Based on this information, the British Admiralty sent to the area a submarine flotilla, which sunk quite a number of tankers, and by this successful action the fuel supplies never reached Rommel's army. It is worth noting that the vanguards of the Africa Corps consisting of motorcycles and light-armored cars arrived at Borgel-Arab as near as twenty kilometers short of Alexandria and were either killed or caught and held

prisoner by the British, as no unit of the German army had escorted them.

With Rommel then at the gates of Alexandria, all effective units based in Syria, Lebanon, and Palestine were ordered to deploy within a few hours at the El Alamein strait. In the midst of their course, the First Greek Brigade, under the immediate appointment from Cairo of Colonel P. Katsotas as its commander, set off in a large convoy of about three hundred thousand men and mechanized vehicles, anti-tank weapons, Bren carriers loaded on platforms and, in general, all the necessary equipment of an up-to-date war unit.

We left the Palestine camp Kafriona at night, and it was dawn by the time we arrived at Kantara and crossed over the Suez Canal. It was a first for a convoy of military vehicles to move at an average speed of fifty kilometers per hour. Usually the speed of such a convoy did not exceed an average of thirty to thirty-five kilometers per hour. The orders were to reach El Alamein's defense line as fast as possible. Leaving behind Port Said and a deserted Alexandria, we arrived at our destination around midnight and came to a halt three to four kilometers behind the front line. We were to sleep there and in the morning take our positions. Sure enough, at the crack of dawn I began to realize that a huge army was gathering in this famous twenty kilometer strait from the seashore of El Alamein to the Qattara Depression.

El Alamein proved very lucky for the Allies. In this narrow passage, General Auchinleck's British forces managed to entrench in El Alamein under retreat and contain the exhausted armies of General Rommel, which despite being out of fuel supplies were nevertheless advancing toward Alexandria. These British forces, though, faced a peculiar situation. The morale of the men after the fall of Tobruk was very low. Rommel's reputation as invincible had gone so vividly around that it proved very difficult to make an army, as large as it might be, effective and in fighting condition. It was also known that the Alexandria and Cairo military headquarters had moved to Suez and that everything was at the ready for Rommel's advance in

Egypt. Even the German song "Lili Marlene," which upset the British whenever they heard it, was now sung in English to overcome their fears and discontent. In general terms, Rommel, although not invincible, had the reputation of a supernatural being and was looked upon with awe.

A typical story went as follows: It is well known how easily one can get lost in the desert. One day before the battle of El Alamein, Rommel was inspecting his units alone with his chauffeur in his six-wheeled Mercedes. He did this without any warning so as to check their fighting trim. He lost his sense of direction, because the day before a sand storm had shifted the dunes, and he saw from afar two very large German-type tents. When he arrived there he got out of his car, went in, and to his great surprise came face to face with speechless New Zealand officers, doctors, nurses, and wounded men. Rommel gave them a military salute, turned on his heel, got into his car, and left. The New Zealanders' reaction was only human, for it was inconceivable to see with your own eyes superman Rommel in your tent—tents which, by the way, were German loot used by the New Zealanders as they were conveniently very large.

The first English move was the replacement of General Auchinleck, whose name was closely knit with the fall of Tobruk. In his place, a new general arrived; the English propaganda had successfully circulated the idea that this was the man that would smash Rommel. This man was General Montgomery.

"Monty," with his Australian Stratson hat (he later used the black beret), began visiting and inspecting one unit after another along the twenty-kilometer defense line, organizing his positions and boosting the moral of his troops. At long last, the Eighth Desert Army had found the right leader. This very fast reorganization was Montgomery's greatest achievement, for on the night of August 30, 1942, a few weeks after assuming his command and two months prior to the

great battle of El Alamein, Rommel launched a storm attack with the aim to reverse the front line break up the Eighth Army and occupy Egypt. He was so determined that at the time of the offensive, he said, "Now or never." Unfortunately for him, it was never.

His armored and mechanized divisions advanced for about ten kilometers, creating a wedge at the El Alamein line, but there they came up against a fierce resistance of a combined armored counter attack, resulting into a huge clash of tanks known as the Battle of El Halfa, where the German Generals Bismarck and Nehring were killed.

On September 5, Rommel was finally obliged to withdraw to his old position. Already, his hopes to occupy Egypt were minimal.

By early October, Montgomery had prepared his own offensive by gathering a multinational Allied army unusual in numbers for only a twenty-kilometer wide front. He deployed his forces from the north—near the sea—to the south, along with the Australians. South Africans, New Zealanders, and Hindus, followed by the hand-picked Scottish "Highlanders Brigade," and next to it General Katsotas's Greek Brigade, De Gaulle's "Free French," and, lastly, at the Qattara Depression, the English First Army Division.

Facing us was Rommel's truly genial battle order. Across the whole front line, he placed his own handpicked units next to the Italian brigades he feared could prove weak points to his front. So he placed between the Italian brigades of Trieste, Bologna, Littorio, Brescia, and Arriete two parachute regiments and three armored divisions of the famous Panzer Division. Opposite the Greek Brigade was the Brescia Brigade and, as Rommel was apprehensive about placing the Italians opposite the Greeks, he added three German parachute battalions.

All this waiting at the El Alamein front lines from June to October 1942 wasn't in effect only that. We were continuously on a war footing, as every night during patrols there were clashes. The Greek Brigade made many displays of bravery during this waiting period,

and the English held in great esteem this Greek military unit, famed since the Albanian Epic. Particularly early in September, prior to the general offensive, one night a Greek patrol advanced through the minefields. Reaching the Brescia outposts, they entered into battle with an Italian unit, which was put to flight, and they brought back seven Italian prisoners. The Greek patrol lost two men. The news of this episode spread at once to all the British units, and the admiration for the Greeks was at its peak.

Waiting is sometimes more exhausting than the battle itself. The continuous patrol actions each night in the pitch-dark vastness of the desert, where you can easily lose your sense of direction, our scrapes very often in the minefields, and the frequent loss of comrades in these daily small operations had begun to tire the men. In addition, the living conditions in the trenches under the scorching sun during the day, the freezing conditions at night, the continued ordeal of the flies—all this before we even had the hundreds of dead—intensified the torture of the waiting.

As I said before, the only pleasant moment of the day was when the red-hot sun set behind the sand dunes followed by the cool of the evening before the night frost. On such an evening before the great battle, we were visited by Sofia Vembo,[7] who came from Alexandria.

She sung for us and reminded us that somewhere far from the horror of the desert, we had a country and a home, a mother and many dear ones that we may never see again. While she was singing, I was thinking of home with running eyes, but I was only eighteen years old. What about the other grownup men crying like little children all around me? I remember that song to this day:

> "When, but when will there be peace, peace?
>
> "When, dear God, we ask you, when will we return to our Greece?"

7 *Equivalent to Vera Lynn*

Vembo left us silent and bitter. As to when the time would come for our return to Greece, we still had a long way to go. Many months lay ahead of us in the unfriendly desert, and all of 1944 at the Italian front.

A few days after Vembo's visit on the night of October 23, Montgomery's Eighth Army counted sixteen hundred cannons that opened fire at ten o'clock in the evening in an artillery barrage. A battle like this (such an awesome affair, full of danger, glory, bravery, fear, and all these mixed-up feelings) gives one an invisible strength.

Night became day, with flashes coming from everywhere—flashes from the guns, flashes from the shells, the drone of the airplanes, and the hundreds of bombs falling on the enemy positions. I was terrified at the mere thought that I could be on the opposite side only one-and-a-half kilometers away in the hell coming down from the skies. The most terrifying flashes and noises came when the aircraft bombs missed their targets and fell on the minefields. It was horrific when a bomb fell there and caused the simultaneous explosion of a few mines. Midnight was nearing, and we knew that at exactly twelve o'clock the guns would go silent and the actual battle would begin. Our mouths went dry. Suddenly there were no more flashes; everything went quiet in complete darkness.

A few seconds later, the pipes of the Scottish Highlanders were heard in the unit next to ours. The Scots took off. Their bagpipes were not heard for long, as our lines got enveloped in smoke. The Italians had begun firing back, and the Greek company set off as the Scots did, with fixed bayonets followed by the machine gun platoon I was serving in a mortar platoon, and, at the rear, the Greek and British artillery. We caught the Italians napping, occupied their positions, and sent back to our lines many Italian prisoners of war. We were later informed that we were the first to come into contact with the enemy. In fact, as soon as the guns ceased fire, Katsotas had sent into battle his first battalion.

Up to this point, one could more or less assess the situation as to the outcome of the first night's events. In battle, confusion always

prevails, much more so during such a battle in the desert. The brigade pushed forward at a slow pace, with the stubborn resistance coming only from German parachutists. The Italian Brescia Division, "troops of a lower quality" as described by General Nichols, did not cause many losses to our brigade.

Here the battle was given with small Bren carriers, armored vehicles followed by infantry. On the night between October 25 and 26, two days after the outbreak of the battle, the Greeks were issued with orders to seize the area of Height 104, as it was called, occupied by Major Bukhart's parachuting men. The well-organized Germans commanded all the accesses.

The Greeks advanced about one kilometer from their previous position, but, when reaching stronghold, they were met with heavy artillery from the side, while ahead of them antitank obstacles and thick wiring proved insurmountable. Given the situation, they had to withdraw, having nevertheless caused many casualties to the enemy. The casualties on our side were three soldiers killed, five officers and twenty-eight soldiers wounded. On November 1, the ninth day into the battle, the situation was still critical. That night, the Greek Brigade was ordered to move its main body against the Italian Brescia division, and that is when the oddest thing occurred.

The men of the Brigade hastily penetrated the predetermined zones through the minefields, and when they reached the Italian trenches, they found the posts abandoned. It was a pleasant note during this difficult time full of sleepless nights and exhausting days full of danger and fear—for everyone is afraid of war.

We occupied the Brescia positions, where we found a great amount of every kind of war material, and rested there for two days. At noon on November 4, we went out into the open, our destination this time being to conquer Height 104. Our Brigade's armored vehicles went out first moving toward the Height. The Germans replied with their artillery, and we suffered heavy casualties. At this point, the vehicles were leaving great distances between them, and without stopping anywhere they advanced through the hell of fire and ar-

rived first at the Height, immediately followed by the infantry with bayonets fixed. After a fierce hand-to-hand battle, the Greeks seized Height 104. Hundreds of Italians and Germans were captured, as well as hundreds of vehicles and abundant war materiel. This operation had lasted for fifteen hours, and many Greeks lost their lives. At dawn on November 6, British General Nichols came over to congratulate Colonel Katsotas.

On the twelfth day, the battle of El Alamein took a new turn. On the entire front, General Montgomery's units broke all of Rommel's defenses. The outcome had been decided and had changed the history of the world.

The day after the capture of Height 104 and Stronghold A of the Qattara "box" by the second mechanized column, we went in pursuit of the enemy. We pushed straight into the desert and not via the coastline, as we wished to reach the rear guards in time, which had remained deep in the desert. Apparently though, as we were told by the few German prisoners we caught on the way, the main body of the Germans, having taken all the mechanized vehicles from the Italians, went north following the coastal road to escape English pursuit. This information was confirmed the following day, when we came across a very pitiful spectacle.

Suddenly, we saw a body of soldiers, tens of thousands, maybe as many as a one hundred thousand, Italians, coming unarmed in our direction, hands above their heads as if ready to embrace us shouting, "Acqua, acqua, auto!"[8]

The scene was not only pitiful but also tragic. They had dragged their feet in the sand under the burning sun without water, God only knows for how many days, with swollen lips and tongues holding up pictures of their children whispering "mio bambino"[9] and begging for a drop of water.

They wanted to join us and were trying to reach Alexandria,

8 *Water, water, help us!*
9 *My child*

which was ninety kilometers away. None of them could get there alive. We were going in the opposite direction anyway and had very little water ourselves, but still gave some of it to the ones who were badly swollen. We went on. We could no longer be delayed. We later heard that the English found them, and they were all saved.

Driving day and night in shifts so as to reach the Germans in time, only the fourth night did we come across a group of Germans with a broken-down tank. They surrendered without resistance. We could not take prisoners, so we disarmed them and just left them there. The following night we stopped. It was pointless continuing at this speed. The brigade's entire unit came to Agedabia in the middle of the desert to rest and catch some sleep.

At seven o'clock in the morning, queues formed outside every company for the usual tea call. It was then that the drone of an airplane was heard from a great height. It could have been an English plane, but we should have known better than that. At this height, it could only be an Italian one, and so it was. God only knows what it was doing up there.

The pilot, seeing the queues, thought to himself, "I have two bombs. Let me throw them here where I can cause some damage."

True enough, one of the bombs fell at some distance, but the other fell on the soldiers queuing and right into the tea cauldron. Of course, no one was expecting a bomber there, and especially not one of a broken enemy. The Artillery company was the lucky one—fourteen killed and many wounded. Such bad luck for these poor kids that a coward Italian should blindly from a height of two thousand meters let his bombs go!

We buried the dead and set off. The march in the desert was exhausting but free from danger other than that posed by a forgotten mine. Not a single German specimen was to be seen other than many dead ones. In their haste, they didn't even bother to bury their dead. We changed our direction and went north but found nothing there either.

After Agedabia, within twenty-four hours we reached Benghazi, a very pretty town. In all honesty, the Italians had done wonders in this field in North Africa. In Benghazi we had a bad experience from a Stuka's air raid that reminded me of Tobruk. Luckily, no one was hurt. After one more week by convoy in the desert, we arrived at El Aghelia and came to a halt. The Americans had landed the day before in Tunis, and Rommel was now doomed. From our side, he was being chased by Montgomery's entire Eighth Army and from the other by Eisenhower's Americans. He was left with no route of escape and flew by air back to Germany. What was left of the famous Africa Corps escaped by boat from small harbors still held by Germans. A large part of the main body of the German army was able to leave form Libya's capital Tripoli, which their rear guard was still holding for such an eventuality.

From El Aghelia we began our way back, fortunately from the shore this time. We returned to Benghazi, went on to Bardia, past Bardia and Derna, and reached Tobruk. Tobruk was exactly as we had left it, a heap of rubble. Luckily, we left it quickly behind us, as my memories of this place were far from pleasant.

Following the coastal road after Soloun and Sidi Bahrani, the Brigade arrived at El Alamein. We buried our dead at the site where there now stands a marble war memorial, a reminder that among El Alamein's nine thousand dead, some hundreds of these youths came from the enslaved Greece.

After that, the Brigade retired to Egypt for the "warriors' rest." Unfortunately, as the saying goes, the Greeks kick the bucket after they have milked the cow. The First Brigade, this heroic unit admired by all the Allies for its deeds, after having retired to Egypt, mutinied against the English because they were influence by the communists in Greece. The English disbanded the brigades, and those who up until that point had been admired were now looked upon with contempt. I felt embittered by all this and, of course, had no part in it—for I was a soldier and soldiers only fight. The politicians are those who cause revolts and wreck what the soldiers achieve putting

their lives on the line.

The English cleared about two hundred of us as nonparticipants and sent us to Beirut, detached to a large French barrack in a town named Caserne du Francais d'Esperay. D'Esperay was a French World War I general, and the barracks were named in his honor. In fact, the whole of Lebanon and Syria were French protectorates, and everything there was oriented to France: The language, behavior, way of life, even the style in which these cities were built reminded one of France. In these barracks was a "Free French" de Gaulle unit as well as a British engineer unit. We were detached to the British one and undertook the repair workshop for mechanized vehicles. Life here was rather pleasant, as I discovered soon after my arrival. First and foremost, we slept in dwellings and on a proper bed instead of under a piece of tent cloth buried deep in the sand as if in a grave. At five in the afternoon, our duty at the camp was over, and we were allowed to go out into town until the eight o'clock parade—more of a hotel life, so to speak.

In the meantime, I had been promoted to the rank of Sergeant, which also meant a higher pay, and my chest was decorated with a few more medals like the Military Cross and the DSO, which I collected at the El Alamein battle for some heroics, I did not get the DSO for nothing; I gained it full-heartedly, as neither mind nor logic are in play at such times.

I was out on a night patrol with some of my men on the fourth day of the battle of El Alamein, ordered to inspect the minefields facing my machine gun company, in case the Germans had cleared a path in the minefields to enable them to get to us. Patrolling around a small sand mound, we heard a moaning sound.

"What do you hear, Stavrakas?" I asked one of the soldiers from Mani.

Stavrakas, a fearless soldier, answered, "Someone is giving birth sir."

"Just tell me what you hear," I said, annoyed.

The moaning now was more intense and was coming from inside the minefield. We stopped and tried to discern something in the glitter of the stars but could see nothing.

Then, another of the soldiers, pointing with his hand at the sand, said, "Here he is, Corporal, sir."

And, true enough, there was a small mass in the sand at thirty to forty meters distance from us.

"He is right in the minefield," I told them. "How can we get him out of there?"

He heard us, and shouted weakly, "Here, here. Help."

"Stavrakas, come here. You will tread exactly over my footsteps.

Come on, let's go. We are going in."

Actually, for someone who knew what he was doing, it wasn't that dramatic. It seems the wind had blown the day before and partially uncovered the mines.

As I was getting ready to go in, my soldier said, "Don't go, Corporal, sir, it is a trick. It must be a German who will knife you as soon as you get near him."

Of course the Germans used these tricks often enough, but I did not believe it to be the case. Nevertheless I spoke in English to the man to make sure of his accent.

"What's your problem?" I asked.

"I was out on an inspection when I lost my way and fell on the mine."

Sure enough, the accent was perfect. "Let's go, Stavrakas."

I went in, treading carefully between the mines as they were very dense, while talking to the Englishman and still feeling a little apprehensive. When I arrived by his side, I saw him lying in his own blood. On his shoulders were three stars and one crown. My God,

a full colonel—the man was an award. He at once promoted me for bravery and gallantry and bestowed on me the DSO. This is how I found myself in Beirut as a fully decorated sergeant. A full one!

When I found him, the colonel was holding his leg, moaning and rubbing it. But this leg was not hurting. It had been cut off from the knee down. He had lost a lot of blood and was ready to faint. Stavrakas got hold of him from around his waist, and I grabbed him from his shoulders. We made our way out carefully, treading on our footprints. In the meantime, the Colonel was no longer speaking; he must have fainted.

Then came Stavrakas's reaction: "Imagine if that son of a bitch is dead, and we went in there for nothing."

"You can demand an indemnity from his heirs," I answered back.

By then we were out of the minefield all in one piece. We rushed the colonel and his leg three hundred meters farther down where we had left our jeep and drove back to our company. The British were notified and came to get him. We were later informed that he had escaped death—minus one leg, of course.

After the battle of El Alamein, I was mentioned in dispatches, the citation being for saving New Zealand Colonel Thomas Wilkinson by endangering my own life.

Good for me, I thought. I asked, "What about Stavrakas? Doesn't he get a citation?"

"No," said my CO, who was a splendid man from Kavala named Nikos Mentzas. "Only rank holders get awards." He at once promoted me for bravery ad gallantry and bestowed on me the DSO. This is how I found myself in Beirut as a fully decorated sergeant.

THE GENERAL'S DAUGHTER

In Beirut, my old Athenian self came to the surface, and it is where my character and personality were formed. I developed into the person I would be for the rest of my life. After all, it was the period when a youngster becomes a man.

In this city, very much under the French influence, the oddest and most peculiar army units serving on England's side were assembled. Though the murderous war was only a step away, here the atmosphere reminded one more of Paris in the prewar peaceful years than a belligerent harbor in the tempestuous Mediterranean Sea.

There was no blackout here—only bright lights, nightclubs, women of every type and description, dubious French and Lebanese tycoons whose fortunes were made unexpectedly, and heroes...like myself.

Many French from different units could be seen, even foreign legionnaires in their colorful uniforms, British (mainly naval men), Poles, Yugoslavs, and other Allied riffraff who had fought somewhere and were brought here to "rest," turning this city into an Allied brothel offering every possible kind of entertainment.

It was a significant and incredible period for me. This strange war atmosphere full of grandeur could not only be found in the bat-

tlefields and the dark desert nights lit by the firing guns, but also, more vividly so, in the glamour of cities like Beirut, Alexandria, and Cairo.

One hesitates to describe all this, for today's reader cannot fathom the reality of it all. How can anyone understand that we acted out life during the night and played with death during the day, that every living day was full of life, that we took pride at the idea that the following day we may never see another night! How can they understand this, pray tell me, with today's men driven only by money and securely shut inside the freshly painted four walls of their comfortable homes, with very few exceptions? Or how could the new… cafeteria generation…get this? How can I believe in those who have offered absolutely nothing to anyone other than to themselves and in those who readily and superficially criticize only to justify their existence and incapacity? When I say "those," they know exactly whom I am referring to.

I did things during the war I could not explain even to myself. I knew what I wanted, and when I set my mind to get something, I did so forcefully and sometimes even violently. Yet, remembering the madness and harshness of that period when every sensitivity and feeling in me had been bulldozed over, I caught myself crying one evening. It was September 14, 1943, when a sailor from the submarine base came to announce that submarine *Katsonis* had sunk and my brother-in-law serving on it had been killed. I loved and admired him; he was a daring man and the husband of a sister I also loved, though I never admitted this nor ever told her so.

To this day, when I look at the pictures taken at the time with my war companions and friends, I cannot believe that out of those war giants not one of them is still with us. Maybe they are the lucky ones not left to witness the spineless little men inhabiting our country today.

Eight months of my life in Beirut had gone by in an orgy of women, drunkenness, and debauchery, keeping company with men

whose backgrounds I had nothing in common with, like Alik Zulganter, who was a Russian prince and legionnaire. I was neither a prince nor an outcast who would end up as a legionnaire.

I still remember Alik telling me, "You drink like a Russian, live like a prince, and have the temper of a legionnaire."

Only when I lived in Beirut could I have lived that part of my life. After everything I saw with my own eyes during the eighteen months in the desert, no one could expect me to be a nice young man, and no one could judge me for my actions. Beirut was a school on human relations. I met there the kind of people no one could dream existed. Men of noble birth turned into war mongrels, men born in shacks and brothels who became powerful informers and squealers, Russian noblewomen who ended up as whores, and whores marrying army generals. Everything and anything could be found in Beirut's "gardens," and because war can make strange bedfellows, one of them was Prince Alik. The other was Yugoslav Michailovich, a drunken reveler who professed to be General Michailovich's nephew.

Third in the group was "Mr. Players." I never knew his real name, but I gave him that nickname because he looked like the sailor pictured on the Players cigarette box. His father, an English Navy officer, had apparently picked up his mother-to-be in a nightclub in Nice during World War I. Mr. Players was now a sublieutenant in the submarine flotilla based near Beirut, but for the whole of that year I never saw him getting into a submarine. The fourth was Bor, the illegitimate son of Harry Bor serving in the French Cavalry which was considered the noblest corps of the French army. Of course, I never saw him mount...a horse, I mean.

These were more or less the individuals I befriended in Beirut and, believe me, I learned a lot from them!

My life then, as I remember, was like a high-quality movie. Imagine today shooting a modern version of *The Three Musketeers* (in this case we were five) in a wartime atmosphere in cabaret settings with eastern Emirs, fat belly-dancing women, aged Russian noblewomen

opening their homes to officers and luring them into marrying their daughters, fairy-tale parties given by the elite, legionaries going to brothels and having done what they went there for, throwing their whore out of the window from whichever floor they happened to be, and my friend Aliossa's pub, where vodka ran out of the mouth of embalmed bats.

Beirut branded my life. In the desert I was afraid of the war; in Beirut I was afraid of my own self. During the entire period of the "soldier's rest," I was drinking two bottles of vodka every night, and I am still alive without suffering from cirrhosis of the liver.

I remember one night dancing in a nightclub with my official, so to speak, girlfriend, a renowned Russian beauty princess called Tanya Natsevanski. As I looked up, I saw I was under a chandelier and counted thirteen lights. Pretending it was a sign of bad luck I took out my gun, fired at it, and shot the thirteenth bulb. Tanya very often gave parties at her fantastic home in Arayia at the foot of Mount Lebanon for the crème de la crème of the Lebanese society, and these parties went on until noon the following day. I am sure she needed an army of workmen each time to repair the house after we had done with it…but we did have great fun, and she loved having us.

You see, unfortunately for her, she was in love with me. The inseparable five international warriors in our colorful uniforms, with our good humor and our conquests and brawls had become the core of social life. We were the first to be invited at every top function, reception, and party. Our success with women was limitless, and whatever we did there, however preposterous, was not only viewed with tolerance but considered daring and full of dash, almost heroic.

Every evening, we would hang out with my friends at the Saint George hotel bar, in a French prewar-style hotel built by the sea and decorated with great finesse, offering first-class service and a Greek barman. We permanently kept two rooms there to cater for the needs of all five of us.

At the bar, while still on our first glass of vodka, we would de-

cide where to go next and with whom, but wherever we went and regardless of the hour, when our outings came to an end we always ended up at Aliossa's.[10] Alexander was in his fifties, a former captain in the Tsar's army who had fled Russia, chased by the Bolsheviks, at the outbreak of the 1917 Revolution. No one knew how and when he had arrived in Beirut.

However, just before the war, he opened this pub where all the Russian refugees met, and there were many of them, from every social class. Princes, noblemen, and low-class small-timers—but naturally mainly noblemen, as the Bolshevik Revolution was, after all, directed against them. Alexander was Caucasian and had given his pub the appropriate atmosphere. One truly felt as if one were in the Caucasus. There were only long wooden benches used for tables, and everybody sat with anybody around them on stools. The walls were painted in black and gold and embalmed bats hung nailed to the walls, bats and crows. Under each one of them was a little switch. When turned on, vodka ran out of their beaks. During my years in Beirut, I must have drunk an entire swarm of owls and bats. Aliossa played the accordion, another Russian the piano, and a wild-looking Caucasian, the balalaika. All three sang, and when they didn't, we sang, led by Alile in Russian though we couldn't understand a word of it. Many years later when I lived in Paris and went to Russian cabarets, I astounded my current girlfriend by my knowledge of all the Russian songs and words.

It was now July 1943, and I had been in Beirut since the beginning of the year. In fact, it was July 14, and the French were celebrating their national holiday, namely the "quatorze Juillet," the day of the fall of the Bastille and the outbreak of the 1789 French Revolution. In Beirut, it was a habit to put up entire Parisian neighborhoods in the park on that day. One could see Montmartre, Saint Germain des Prés, Montparnasse, and many others, with their bistros, cafes, and cabarets just like in Paris. On this site, the French Governor

10 *Alexander in English*

General of Lebanon, François de Grèze, gave his annual great ball. Not only were members of Beirut's high society invited but also the elite of the Syrian and Egyptian French community. The French were impatiently expecting this ball. When you know that you can catch a plane and be in Paris in three hours, setting a make-believe Paris in Beirut is of no value, but when you know that Paris is under German occupation, and its people are starving, then finding a corner of Paris in a foreign land turns the yearning into tears.

The day before the ball all we did was wash our shirts, iron our uniforms, and shine our medals. The more we shone, the better our chances for getting ourselves set up. So on the evening of July 14, we started off ready, shining, and willing, first passing by Aliosa's. We knocked back two or three vodkas to get rid of any misgivings, and when it got dark, we made a triumphant entrance at the ball. We were late, of course, and arrived after the French Governor. This created a sensation among the guests and displeasure among the high-ranking officers.

Due to the special missions and services we had supposedly rendered in Beirut, we had become a state within a state—the word *discipline* was very relative—and our superiors were very understanding. We had gone so far as to alter our uniforms, smartening them up. Instead of the khaki-colored tie, we often wore colorful foulards,[11] folded our sleeves carefully, and did not wear our epaulettes and decorations—more like gentlemen on their way to play golf than soldiers going to war. As I said, all this lent us a special glamour, especially with the ladies.

So, once more we became the center of attention at the ball. The spectacle was magnificent. The lights, the colors, the uniforms, the decor, and the evening gowns of countless beauties reminded me of *One Thousand and One Nights*.

Michailovich and I were separated from the rest of our group.

11 *Neckties*

Alik and Mr. Players had disappeared in the small alleys of the setting. Bor had earlier been absorbed into a circle of women, but we had now lost track of him. Unhappily, we were pinned down by the respectful Princess Anne-Marie Stepanovich of Serbia and Croatia, who was trying to convince my friend that he should be proud of his uncle who was a general struggling for the liberation of Serbia. Speechless and bored, Ivor was patiently listening to her while casting desperate glances at me, thinking of a way to escape. As if by miracle, a deposed Serbian ambassador appeared, who, after having kissed the old princess's hand, to our great relief picked up and continued the conversation. Seizing this unique opportunity, we hurriedly left in order to go and wet our throats.

Amid the illuminated alleys of the make-believe Paris, we walked in and out of bars looking for our friends, downing a glass of vodka each time, until I saw a sign reading "Casanova," Bo î te Russe, 19 rue du Siècle—a perfect replica of the renowned Paris nightclub.

"Stop, Ivor. Look no more," I said to him. "Here we are. This is the place to find the others in."

Without another word we went in, only to witness the following spectacle: Behind a long, Russian bench covered with a red velvet cloth sat five of the most beautiful French girls. Bor and Mr. Players sat among them, hugging two girls each. The girls in turn were filling their glasses with vodka and washing it down their parched throats. Standing in the grand uniform of a Caucasian sergeant was Aliossa, who was running the place for the evening and who played his accordion to the accompaniment of balalaikas played by two uniformed, bearded Russians. In the center of the floor, Alik danced a wild Caucasian dance with a knife in his mouth. According to the rhythm of the music, he would nail the knife on the floor with his mouth and, opening his legs wide, grab a glass of vodka with his teeth, drink it in one gulp with a backward move of his head, and then throw the glass to the floor with another move of his head. There it would shatter into pieces, followed by hysterical cheers. Another glass was placed

on the floor, ready to be clutched by the fierce lips of the Caucasian prince, and another, and another.

I lost track of the times Alik went up and down and the number of glasses of vodka he drank and broke. When the music stopped and he finished his dance, he walked with a steady gait, unbent like a cypress tree toward the table; pulled the knife from his mouth with his right hand; and with a ferocious yet graceful movement, cut off both shoulder straps of the dress of one of the ladies resting in Mr. Players's arms.

The dress fell off under the weight of the French lady's bosom and revealed it to common view. Like a gallant knight, Bor jumped up and with his red legionnaire velvet cape covered the lady's naked breasts. More clapping for Alik's daring gesture as well as for Bor's gallantry.

Michailovich and I were already drinking, seated at the same table among the ladies when an incident occurred that was to become a landmark in my turbulent life. The curtains covering the doorway were gracefully pushed aside, and at the entrance stood a beautiful "swan," one meter and seventy-five centimeters tall, with red hair and green eyes. Be brave. First come, first served, I thought, and with a jolt was standing in front of her. One had to be decisive in such cases, especially as the rest of the gang were barbarians, and there was no time to lose.

The swan was taken aback, her eyes flashing half in anger and half in surprise.

"Si on s'asseyait tous ensemble,"[12] I offered, extending the invitation to her escort, a French lieutenant. Before she had a chance to refuse, I took her by the hand and led her toward our table but cleverly changed direction at the last moment and whisked her to another empty table nearby, so as to isolate her from my savage companions.

Neither she nor her French escort fully realized how this hap-

12 *How about us sitting all together?*

pened, and then we were seated at the table, already having our first vodka. In the blink of an eye, Aliossa and his accordion were upon us, creating the right atmosphere and leaving no room for questions and objections. The speed of the operation was such that expressions of bewilderment and embarrassment could still be seen on their faces.

The first phase had been crowned with success though the first dark clouds did not take long to appear. I could feel the eyes of the others piercing my back like needles, and soon a bottle of vodka arrived at our table "with our compliments," an omen that the barbarians would soon be upon us. In a desperate attempt to save the situation, I returned the bottle with the message, "The lady thanks you but only drinks tea," knowing full well the disgust provoked at the mere mention of the word *tea*. It seemed to have worked, for we were left in peace for the rest of the evening.

Now I had to get down to work using my known tactics in order to find out who this lady and the man escorting her were, and most importantly if they knew who I and my friends were. You see, one's reputation and past are the best allies in such ventures. As to our reputation, she must have had some knowledge, for she kept on asking if we were all part of the international unit and seemed to be knowledgeable in army and personnel matters. The one who was completely in the dark and knew nothing about the other party was me. This lady was a mystery, and the bespectacled lieutenant by her side a nonentity. He could neither be her lover, as they did not fit together, nor her husband as his behavior was rather submissive.

Meanwhile, having used up all the jokes of the repertoire I had at the ready as an initial striking tactic, I took on my most charming expression, and we now looked tenderly at each other.

"Shall we go somewhere else?" I suggested.

"Let's go," answered the beautiful lady, and immediately the French man stood up and held her chair to help her get up.

My, my, I said to myself, but who is she? I asked Aliossa for the

bill, and as he approached he whispered in my ear that the tag was on him. I couldn't believe it! Who, Aliossa who usually made us pay for the bottle of vodka before we even had a chance to wet our lips! He then, with a nod, made the lieutenant understand that he should take his leave. At once, the ally kissed the lady's hand and almost kissed mine, bowing so low, and off he went. By then I felt so disoriented by all these happenings that the only solution left for me was to turn cute.

"We have dismissed him. He is gone," I said with an idiotic smile on my face.

"Yes," answered the lady. "Many congratulations. He is a higher-ranking officer. That doesn't matter."

"That doesn't matter to you," I replied, always in jest. "It matters to me though, and will bother me even more so tomorrow when he will seek me out."

She smiled. "He will not find you."

Aha, I thought miserably, you will go of an inglorious death, my dear friend. Besides, as things stood, either something very bad or very good would happen, so courage, go ahead, the girl is a doll, let's have fun and at least die happy. As we were walking under the trees in the park, I took her in my arms and kissed her without any resistance on her part. It was obvious that we both enjoyed this very much, and we stood there for a long time. The passersby did not disturb us.

From there onward, I remember only vaguely what followed. We strolled in dark alleys, going in and out of several bars, drinking and drinking and drinking. Finally, I could no longer stand on my feet and neither could she, but I had no intention of giving up easily.

"Where do you sleep?"

"At home, of course," she answered, a little annoyed.

"Come, let's go to your house then," said I, making my inten-

tions very clear.

She smiled, and I hailed a taxi. She gave an address, and after a while, the cab stopped in front of a small iron gate. I had no idea where we were or how long it took us to get there. I must have fallen asleep on the way. Judging by the cab drivers kowtows, I paid him a small fortune. I got out, pushed the small iron gate open, and pulled her inside, certain by now that I had got myself a maidservant for the night, as the house and gardens seemed huge and very grand, and we were getting in through the back entrance.

I felt some reservations at the back of my mind, but everything was so confused and hazy from all that vodka that I didn't give it much thought and went on ahead. Through a long garden path, we reached the house or, rather, a fantastic looking mansion. Again we entered through a small side door, and I followed her, shoes in hand, as she had asked me to, along endless corridors up small and large stairways until we walked into a completely dark room.

When she undressed, I watched the reflection of her silhouette and realized once more what a gorgeous creature she was. We fell on the bed, and the next thing I remember is someone knocking at the door, which seemed more like cannon salvos in my dizzy head. The door opened without that someone waiting for the usual "come in." My bed companion jumped up, muttering a "Bonjour, Papa!" By then I had covered myself up, but I could peep through the opening in the sheet, and what I saw I could not for the life of me believe. From the shock, my drunken brain began to come to its senses. She had addressed the "bonjour, Papa" to a stout gentleman with a cigar in his hand who was dressed in the honorable uniform of a French general.

Stay calm, I said to myself, after all, what more can happen to you other than a court martial followed by a firing squad? This French general was none other than the Governor of Syria and Lebanon, François de Grèze, and the young lady next to me none other than the honorable mademoiselle Simone de Grèze, Captain of the

women's auxiliary unit of the French general staff.

Oh, you miserable fool, I told myself, where have you come to sleep? At the Pentagon or the general army staff?

Simone and the general had gone outside in the hallway, and I could hear coming from there the harrowing shouts of the humiliated uniformed father and those of the dishonored daughter. Suddenly I heard the thump of a body falling on the floor, and the shouting stopped. God, she must have just told him that the man he found in her bed with was a Greek, and the poor Christian was knocked for sixes.

In those days, Onassis, Niarchos, Maria Callas, *Never on Sunday*, and the later-famous Mykonos island that gave so much glamour to Greece, did not exist. Greeks in those days, in the Middle East army, consisted mainly of lower-class individuals, the majority of whom were refugees from islands near the Turkish coasts—and many other unsavory elements. Their behavior as well as the mutiny against the British did not help either. So you can imagine what it meant for such a creature to be found in your daughter's bed!

Dark days descended on the glorious Greek forces camped in Lebanon: confinements to barracks, no leaves for the officers, etc. No one knew the reason behind it except me, and I could not reveal these reasons for the entire Greek army would tear me to pieces. I was exempt from these restrictions, for, though a Greek national, I was nevertheless serving in a foreign unit. Her poor father had not reckoned on this eventuality, and, while he thought his daughter was safe because the Greeks had been confined to camp, I secretly met with Simone every night. Like all women, she was endowed with the sense of ownership and began trying to keep me away from my companions and all this usual crap. I was never madly in love with her, yet my vanity was tickled by the mere fact that the Governor General's daughter was in love with me. After all, I had nothing to lose, only to gain, through the affair.

One day, the bomb went off. Without my knowledge, Simone announced to her father that she intended to *marry me*. A terrible scene ensued during which mother and father fainted alternatively while adorning the Greeks with the most awful French epithets. Simone threatened suicide, upon which her parents, afraid she might carry out her threat, decided to agree to the wedding.

A wedding we did have, but what a wedding! Only God who witnessed it all could tell what took place in the Beirut Orthodox Church. The mixture of guests was unbelievable: Greek officers, French generals, aides-de-camp, and officers from the Foreign Legion, my terrible group of "international warriors" that had been drinking since morning and it was now past four o'clock in the afternoon, French and Lebanese ladies, and an entire body of deposed Russian princesses. The greatest variety of rank, though, was within the family: father-in-law a general, bride a captain, groom a sergeant. After the ceremony, we all went of course to Aliossa's; the pub had been reserved for the occasion. It was the first time I saw a joint looking like a battlefield. I was never as frightened in battle as I was on the day of my wedding! Alik and some other legionnaires tossed Simone up toward the ceiling every so often, and, thank God, they caught her on her way down. Mr. Players leaned over to tell me, "Do you know why they are doing this? To show her how high she reached by marrying you." Of course, I did not object to it. Had she burst on the floor, I would have commented, "It was a matrimonial accident." Simone survived, and in fact she could not remember a thing the following day. Of course, we were still at Aliossa's on that following day. She woke up on a bench, and I woke up lying across three seats, with the piano stool serving as a pillow. Alik was sleeping on the floor, Bor on another bench, but he had covered Simone with his red baize cape. So much for gallantry. I was rather amused at seeing others looking after her better than I ever did.

Yet that next day proved tragic for me! Not so much due to the drinking bout but to the fact that the General ordered me to leave the barracks and move to the Government House so as to spend the

nights sleeping with my wife. I had already been moved to another camp outside Beirut where a new Greek Third Brigade was founded out of the men who had not been involved in the First and Second Brigade mutinies. So orders were sent to my commander to release me from sleeping in the camp. Of course, the high-ranking officers knew of my marriage and their attitude towards me changed.

Just two days after my wedding, the 3rd Brigade commander called me. "Could you please, my child, arrange a meeting with your father-in-law. There are many problems concerning the Brigade that I would like to discuss with him, and I don't seem to be able to see him."

It only took me a few minutes and a phone call to arrange this meeting. For all intents and purposes, I was now commanding the Brigade. The mere fact that the Greek Brigadier arrived every morning at camp in a jeep driven by pockmarked Manolis, who, in Athens, had been doing the Vathi-Votanikos[13] run in a prewar decrepit old bus, while I rolled up in the Governor General's black Cadillac driven by a French chauffeur with the French insignia flying on the side of the car was more than enough…

This was all very nice, but the merry-making days were over. The General expected us to sit at table and eat at eight o'clock precisely every evening, plus things like frog-leg soup and other such depressing French duties.

The group of "international warriors" had dispersed as Mr. Players finally entered a submarine and left for Malta, Michailovich was sent on a secret mission to Yugoslavia, and of the two that remained, Bor was permanently in bed with some woman, and Alik was permanently with a bottle of vodka in his stomach. I was on the brink of insanity, as, from a carefree warrior, I had become a French petit bourgeois, or worse.

A whole month had gone by since my wedding day, and I lived in deep despair. But, as always in my life, luck was on my side.

13 *The equivalent of Brixton-Tottenham*

One fine morning I was told that my Brigade would be shipped out within the next few days. Destination: the Sicily landing. My heart began to sing, but my mouth was hermetically shut. Not a word to Simone about this news. Of course, my father-in-law must have been advised.

Two days later, six Liberty ships arrived from Egypt escorted by two torpedo boats. My Brigade was to be loaded the following day, and the convoy was due to depart on that same night.

My Commander called me on the eve of that event, and said, "By the personal order of General de Grèze, you are herewith dispatched to the Lebanon French General Staff."

My reaction was far from a military one, yet human. "What are you talking about, Brigadier, sir, and please forgive my language?"

"I only carry out orders. You are dispatched as from now," he replied.

"You mean to say I will become a Greek deserter just so as to be spared the Sicily landing?"

"No, you will not be a deserter. You are serving in the French Army now."

That was it. "Well, then I will become a French Army deserter." The Brigadier got my meaning and, with a smile, said, "That is your problem. Go now." I saluted and left.

I returned home at eight o'clock for dinner, not saying a word, as if I knew nothing. Not a word on the matter from the general either. OK, I thought, they have both agreed not to refer to it. Just wait and see. Tomorrow you will be having dinner by your own little selves.

The following morning, I drove to the harbor where the loading was already underway, to learn my way about. The Liberty ships were tied to the dock, first loading vehicles and then the armored cars. I found out from an English Navy officer that the convoy was due to sail at midnight precisely.

I returned to the camp, which was almost empty, and gave a

friend in my unit a bag with some personal effects in it, asking him to take it on board the ship. I then went home. Simone greeted me jumping with joy.

"My love," she said, "your Unit is leaving."

"I know. Tomorrow…" I replied, to confuse her.

"Yes, and Daddy has made all the arrangements for you to stay with us French," she now admitted.

I didn't say a word.

"Aren't you pleased?" she asked.

"I am very pleased to stay with you but not about leaving my unit."

At this point, Simone got a little mad. "But haven't you been through enough? Haven't you served Greece well enough? What sort of people are you Greeks?" She then went on to repeat, "Mon Dieu, mon Dieu!"

I didn't answer, as it was not to my advantage to get into a fight with her. We had dinner, and the General asked me to present myself at his office the next morning.

"D'accord," I replied, and then offered to take Simone to a movie.

I chose the Roxy in the Place des Canons, knowing there was a taxi rank just outside. The film was on at nine o'clock and playing *Suez* with Jean-Pierre Aumont and Maria Montez. The intermission was at ten o'clock. Simone did not smoke. I did, of course, and this was my plan and what I was counting on. I grabbed a taxi and reached the harbor in ten minutes. Thankfully the ships were all there. I had known which ship I would find my unit on since the day before. I went up the gangplank and at once saw all the familiar faces. Taking a deep breath, I lit a cigarette and leaned on the bulwark. I looked down on the dock afraid I might see Simone standing there. It was, of course, rather impossible for her to find me among three thousand men on six different ships. She was probably watching the end of the movie or about to wake up her daddy and ask him to

stop the convoy!

The daughter of the French Governor General married me out of love. This in itself was an achievement. How can anyone believe that one night completely drunk I went inside the Government House, slept with François de Grèze's daughter, and married her within ten days just to prove that I could always get what I wanted? Then I deserted her. I could have stayed behind, having all the means to do so, but one desertion brings on another. Common sense deserted me, and I deserted my wife. I don't know why I am using the word "wife." I never realized I had been married.

Before we left the harbor, I said good-bye to Beirut, Simone, Alik my Russian friend, Mr. Players, Bor, Michailovich, and a very special good-bye to Aliossa, for the many happy nights and for teaching us the joy of living. Through my blurry eyes, the lights of Beirut faded away. Another beautiful part of my life had come to an end.

ON THE WAY TO RIMINI

For my generation, war was our shadow, an integral part of the background of our lives. I was separated from Yuki without even a good-bye and had to leave Simone without saying farewell.

Complete darkness in a stormy sea. The ships steamed slow ahead at six or seven knots, leaving a good distance between them. All that could be heard was the roar of the engines, the howling wind, and the whistling of the destroyers moving around protecting us from the U-boats. The Mediterranean was full of them.

I went down to the first hold, on which were laid blankets for us to sleep. The mechanized vehicles were in holds number two and three.

In the morning, the weather had improved, and we could clearly see both the ship half a mile ahead of us and the one to our side. We were right in the middle of the convoy, which was a good thing, as the submarines never get inside it for fear of being circled-in by the destroyers. They usually hit the ships on the outer side of the convoy in order to make a quick escape after the attack. In 1943, the ASDlC system, predecessor of SONAR, was available and was able to detect the sound of a submarine and assist the dropping of the depth charges.

Around noon, we reduced our speed and were joined by another large convoy of seventy ships coming from Haifa on their way to Italy. The British had already landed in Augusta having met little resistance, and almost the whole of Sicily was now in the hands of Montgomery's Eighth Army, recently arrived from North Africa. On the other hand, the Americans met fierce resistance as they landed in Salerno, each wave being thrown back to the sea by the Germans. We had no idea on which side of Italy we were due to land.

The following day at noon, the weather was fair and visibility exceptional. The convoy, defying danger in order to gain time, its speed up again to seven knots, came very near the island of Crete, and the unexpected—as they say—occurred. A German, obviously a brave one, brought his submarine to firing distance, despite our escort destroyers and corvettes combing the area, ordered "Periscope, up," and fired his first two torpedoes. One of them hit a Liberty ship on the outer side of the convoy and almost cut her in two.

We later learned that there were eighteen hundred men of the Ghurkha Division, and their vehicles were on board, too. Of course, the men found themselves in the sea, and there was no time for more than one or two lifeboats to be lowered to their aid. As is well known, no ship that is part of a convoy may stop or reduce speed to collect survivors, for this could cause the ships to fall foul. It was here that I witnessed the tragic scene of ships passing the wretched Hindus plunged in oil, calling for help with no one able to do anything about it. Some of us tried to throw them some lifebelts, but our English lieutenant forbade it. As he pointed out, in the event of our ship being hit, there would not be enough lifebelts to go around for us.

War is cruel and has its own rules, one of them being "save yourselves." Of course, if after the convoy had passed the danger zone and some escort ship had not gone in chase of U-boats, she could then collect survivors, if there were any left that had not drowned. This nevertheless rarely occurred, for no warship would risk coming to a standstill and providing the enemy with a fixed target.

By the next morning the cruel images of the miserable drowning Hindus had been erased from our minds. One must only think of pleasant things in order to survive the war. This was a typical beautiful Mediterranean summer's day. We must have been sailing somewhere south of the Peloponnese, and the rising sun was so bright that we could clearly see from afar our islands and the top of our mountains. I'd spent three and a half years away from Greece, fighting here and there in the desert and the rubble, yet I'd been unable to set foot on these opposite shores! It seemed as if the *meltemia*[14] coming down the mountains brought to our ears the far cries of our enslaved dear ones: "Come back to us. We have been waiting for so many years. Enough…" But they had placed their hopes for freedom on our shoulders, and we were once more on our way to fight for our unfortunate country.

Our hearts broke and tears ran down our eyes as the meltemia relentlessly whispered in our ears. We were only human and swayed for a moment. Soon the top of the mountains disappeared from our view, the tears dried up, and the preparations for next day's landing in Italy got underway. At dawn we were only a breath away from the Italian coasts.

Already the British Eighth Army had swept through Sicily and had passed over the mainland. We landed more to the south of Taranta. The infantry advanced without many problems—just a few skirmishes here and there—and the following day our ships entered the harbor of Taranta to unload.

This was the beginning of a third period of hard fighting against the Germans. The reader must not assume that the Germans, after their defeat in Africa and their problems at the Russian front, had become less fierce. Quite the opposite, for they had been told: hold the Italian front at any cost as in a few months Hitler's new weapon will bring the war to an end. They were not lied to. Von Braun's atomic bomb was almost ready, only it did not happen in a few months as

14 *Summer northeasterly winds*

predicted. The Americans got there in time. They got Von Braun and his atomic bomb, and with it they also ended their war with Japan.

After the mechanized vehicles were unloaded, we all gathered in a makeshift camp eight kilometers outside Taranta, which was continuously bombed by the remainder of the Luftwaffe's Stukas.

Our Brigade from now onward was under the direct orders of the New Zealand Expeditionary Force, part of which had fought in 1941 at the Battle of Crete and was the same task force with which we had fought side by side at El Alamein. Its general was none other than the great philhellene New Zealander Freyberg. This man was a passionate admirer of Greece; he was more of a Greek than a New Zealander. Having inspected the entire Brigade, he wished us all good luck and left.

In the new layout of orders issued to the Brigade, my unit was detached to the technical corps for the repairs of mechanized vehicles. Before I could even say to myself, "Thanks be to the Lord—no more machine gun company as in El Alamein, no minefields, no unnecessary dangers," I was told to present myself to the officer commanding.

Captain Dimopoulos was a splendid man and a very knowledgeable one. He was an electrical engineer who held me in great esteem because, out of the three years I served, at least two of them were in the front line.

So he said to me, "Yesterday, the British delivered a great amount of new military stores, in particular mechanized vehicles, among which is a huge American MAC crane. This crane has a platform at the rear capable of towing two Churchill eighty-ton tanks, and I can entrust it to no one but you."

I thanked him and was about to leave and take delivery of the crane, but the captain had not finished with me.

"Furthermore," he continued, "you, better than anyone here, know all there is to know about mines and minefields, and the Ger-

mans have turned Italy into one vast minefield."

There we go again. The minefields, I thought; yet I could not work out the connection with the crane.

"The crane has a workman, meaning that there is a winch attached to it at the front with an eighty-meter-long wire rope wound on it. When one of our tanks or other vehicles hits a minefield and is immobilized in there, you will go with your crane, stand it outside the minefield, take the end of the wire rope, proceed on foot, hook it on the hit vehicle, walk back, and pull it with the winch out of the minefield."

When the Captain had finished, I said sarcastically, "Easy as pie, Captain, sir!" and the man roared with laughter.

By then I had come to realize what sort of a dirty job I was saddled with. You enter a minefield once, twice, three times—well, you are not God, and you are eventually bound to step on a mine when you go in there every day. Furthermore, the man had said that I know all about mines. OK, I though, I know how to detect mines in the sand, but in Italy with all the greenery, the bushes, and the dug-up fields how can one recognize where and if there are mines underneath it all? I went with a pang of anguish to take delivery of the crane, muttering to myself, "How could I have come to this, on the last leg of the war just when I was about to return home…" Yet as soon as I cast my eyes on "Mac" such was my enthusiasm that nothing else mattered.

Mac was a greenish-gray camouflaged beast with such a crane and other machinery on it that the wheels came up to my chest, and I needed all three available steps to climb into the driver's seat. The Englishman delivering it to me was full of words of praise concerning Mac.

"She has fantastic air brakes, a hydraulic steering wheel similar to a facing car, fully synchronized gears, not like those of the Leyland that are impossible to engage a gear in, as well as three differentials

that help her to never get stuck anywhere."

I thanked him, took the beast for a trial run, and then returned to my unit. I found everyone lined up and Brigade Commander Tsakalotos ready to read out a telegram just in from our government in Cairo:

> Our hearts leap with joy at the sight of the blue and white Greek flag waving opposite our coasts in Italy. On your way to glory and freedom the wishes and aspirations of our Nation are with you.
>
> —George Papandreou, Prime Minister and War Lord

"See how high I leap," said Vangelis, the truck driver from Piraeus standing by my side, "when I hear of Papandreou getting all emotional sitting in his armchair in Cairo!"

Vangelis was absolutely right, for we could only laugh when receiving such cables. Can you imagine what it is like to have eaten mouthfuls of sand and to have ahead of us this new Italian stinker and then to have some bloke sending you moving wishes from Cairo? We preferred by far the cable sent to us by General Paget, Commander Allied Forces Italy:

> I would never wish to be under attack by the Hellenic Mountain Brigade.

After less than two days we had to break camp, and at dawn on the third day we were ready to set out. In the meantime, I had to get a crew together, as my beast was in need of one. Firstly, I took on two engineers. Poor chaps. It was to be more of a fatigue duty than anything else: dismantle, reassemble the towing rope, load the tanks, join the brakes, etc. Furthermore, the tires of the platform trailer had to be at equal air pressure at all times, for if a pair of wheels had a flat

tire and one rubbed against another, they would catch fire, burning out the trailer, tanks, ourselves, and the entire crane in the process. Other than the two "engineers," I took on Vangelis the truck driver as a co-driver in case something happened to me.

Vangelis's first job was to send the engineers off to the beach to fill about ten sacks with sand, which he laid across the entire floor of the crane compartment in which we sat, as well as around the clutches. This was standing procedure for our protection since the desert days, to save our legs from fragments in case we hit a mine. Many desert drivers are still looking for their legs.

So, on that given morning, the Brigade set off in column. The military police motorcycles took their position at the head of the column, placing stakes with the blue sign of Athena's head along the route to be followed. Next came the mechanized vehicles and armored cars loaded with infantry men of the First, Second, and Third Battalions, followed by the artillery, with their guns being towed by armored cars, the signal vehicles, the machine gun company, the Engineer Corps, and the remainder of the units. Finally came the repair unit for mechanized vehicles that I was detached to, the last vehicle of which was my own beast.

As Vangelis noted, "Don't rejoice for being the last. As soon as we reach the bam booms we will once more be at the very front."

This man, though completely illiterate, was a born prophet and whenever he opened his big mouth whatever came out of it sooner rather than later came true. When I got the beast's engine started, the top of the convoy was three to four kilometers away. We proceeded unperturbed at a speed of thirty-five to forty kilometers per hour. We passed Monopoli, Vitonto, Foggia, Termoli, and later arrived at Pescara where some bam booms could be heard.

"What is it?" I asked Vangelis.

"Nothing much," he answered. "Whoever is the nearest will clear it up."

And so it was. Five or six Jerries, cut off from their unit, lay in wait to ambush our column and cause some damage. Our people inside the fields nevertheless caught them. Now, how not a single German was brought back alive remained an unanswered mystery!

Outside Pescara, the vehicles were scattered in the fields to avoid them becoming target points and, exhausted, all the men fell asleep. "Mac" offered ideal bedding, as the area in front of the driving seat was two meters long by sixty centimeters wide, which of course I requisitioned! Vangeli fixed his bed at the back of the compartment. The two engineers kept a four-hour watch each and laid their blankets under the beast. We had a quiet night, other than the fact that every time I tossed in my sleep I would inadvertently touch the horn and the others would jump panic-stricken!

The following morning at dawn we were again underway, the column having now dispersed. We arrived after three to four hours in Ancona and cautiously proceeded north. The tarmac coastal road no longer existed, having been wiped out due to the numerous battles fought in that region. The signs of this were obvious because of the burned-out tanks and vehicles scattered all over the place. We moved inside the fields, on dirt roads, up and down bridgeless rivers without as much as a cart road to be found. Especially for my beast, with two armored cars loaded on its platform, the going was very difficult and dangerous. The torrid heat of the Italian month of July and the dust raised by the convoy floured our sweaty faces and arms. We had embarked for good on this new venture and each kilometer brought us nearer to the battlefield. Soon the echo of artillery fire could be heard. The front at that precise moment was just outside Catolica. It was getting dark, and the order for "No smoking in open spaces" was issued.

"Welcome," I said to Vangelis.

He replied with good humor, "Glad to be with you, Sergeant, sir."

Colonel Tsakalotos, our commanding officer, a fearless man but voluble talker, "launched" his first daily orders. These daily orders

inadvertently began with the Byzantine days mixed with a bit of Velissarios,[15] some Constantine Paleologos[16] to our future conquest of Turkey. He would then go on to the Bulgarian hyenas treading on Thrace soil, all of this garnished with lots of Macedonian blood, and he would end with, "The hour has come for the war cry AERA[17] to be heard from your bayonets."

Especially when addressing the troop lines, we had all morning. This, of course, did not occur during operations but at respite times. As Vangelis used to say, "The Germans await Tsakalotos's speech to get us all together in one go." I don't wish to deride those orders, God forbid—quite the opposite—for, though longwinded, they did their job of boosting up the morale of the men.

Yet when he went on to say, "Hellenes, take revenge on behalf of your fellow men, wives, and children," and so on and so forth, at the words "take revenge on behalf of your wives," Vangelis said, "Why should I take revenge for that blooming Fotini, who has been taking her revenge on me for the last fifteen years? Let the Germans bump her off so that I can find some peace!"

There were many reasons for the Greeks to flee their enslaved country and go to the Middle East to fight; some did it for home and country, some for the adventure, some out of hatred for the Germans, and some even out of hunger. Vangelis's reason was to escape from Fotini, and here was his commanding officer asking him to fight for her!

"Not for that blooming woman," he shouted, and we all fell about in laughter.

So, on that night, the three Greek Battalions pushed forward to relieve the more advanced Second Canadian Brigade. During the replacement, and as the Canadians departed, the Germans followed

15 *Byzantine general*
16 *Last Byzantine emperor*
17 *Greek war cry during war against Italy in 1940 that meant take wind*

our every move, and then they fiercely attacked us. The Greeks counterattacked and sent them back to their former positions, but in the morning had to bury their first dead on Italian soil. Among them was Major Stefanakis, who had been at the front line all night. Now the Greeks had to attack in order to seize certain positions twice taken by the Canadians and Poles but lost again to the Germans.

Before dawn, a motorcyclist from First Brigade woke me up. I was ordered by my OC to go and clear some burned-out vehicles and two German light-armored cars from the area where battle had taken place during the night, as the following night we were to deploy our attack with small armored carriers.

Driving behind the motorcycle in the dark, I could hear in the shell-scrapes the moaning of the wounded, who had as yet not been collected by the stretch bearers. Farther below, covered under an oil cloth, were the dead.

Vangelis commented, "Look at that, the ones that complied with Tsakalotos's orders and died have been taken care of, and the live ones have been abandoned."

Just then, an ambulance arrived, roaring through the muddy field. One wounded soldier shouted, "Hurry, damn you, hurry. I have lost all my blood," while another shouted, "Slowly! Take it easy. I'm in great pain; all my bones are broken."

Neither Vangelis nor myself heard or saw such things for the first time; we had both been in Tobruk and El Alamein, and we were, therefore, used to it like the mountains to the snow.

It was then that a lieutenant came running in our direction. "Whose is the crane, Sergeant?" he enquired.

"At your command, Lieutenant, sir," I answered.

"Pull straight in there," he said, pointing at a pitch-black darkness one could cut through with a knife. "You will find three of our burned three-quarter ton trucks and to the left of them two German armored cars. Hurry up and get them out of there before daybreak.

Otherwise, you are done for. The Germans are only one-hundred and fifty to two hundred meters away from where you are going. So, off with you, and take care."

Meanwhile, I had no idea—though I was expected to—whether this was an ordinary field or a minefield, so I asked, "Were they burned by gunfire or mines?"

"No, you nitwit," he answered, "they were careless and got burned by a brazier…There was pandemonium here, and you are asking me what the vehicles got burned by? I don't know. Just go and get on with it—but there must be mines in there."

"Let's go for the glory," said Vangelis, and promptly sat on the beast's front mudguard in order to have a better view, though this was a dangerous position in case of mines. However, using the auxiliary gear, I slowly drove Mac in the muddy field, and after one hundred meters discerned to my right two dark shapes.

At the same time, Vangelis whistled by placing two fingers in his mouth, which meant, "I have seen something. Stop!" I switched the engine off just in case, for, even if we could not be seen, the noise of this beast could surely be picked up. We could faintly hear German voices now, a sign that we were very near their lines. We very carefully approached the two burned-out armored cars on foot. The wheels were intact, which meant that they could be towed away. Of course, I refrained from touching a thing and didn't even bother to look to see if there were any burned-up men inside, as the Germans booby-trapped everything and anything they left behind.

Even when trying to bury the dead after a battle, one could be had, as they placed explosives under the bodies. In the desert when retreating they would throwaway water flasks and if one tried to open one to take a drink his arm would be blown off. Later, when fighting in the towns, the opening of a cupboard could blow up the whole house.

So, without touching a thing, we tied one armored car to the

other by the wire hawser and grapnels—a towing line, so to speak. I rigged the winch at the front of the crane to one of the burned cars and reversed over my own tracks while the wire rope uncoiled out to its full eighty meters length. When it stopped, I began towing with the aid of the pulling block. Sure enough, the two armored cars came nicely along for another eighty meters until the burned vehicles and I reached our own lines. I went back at once to pull out the other remaining three trucks, but there was not enough time left to get them all out, as it was becoming daylight by now, and the Germans began firing at us. The Germans were first-class snipers and could aim straight at your forehead. So, we had to explode the last truck with the aid of a bazooka so as to completely clear the area. But Mac did get his baptism of fire by having been hit a few times.

Back at the battalion, two charred Jerries[18] were found, one in each of the armored cars.

Vangelis made one of his usual comments: "We had our share of roast lamb for today."

Any atrocity was as routine as my job, up until the day, of course, when a mine or bullet would bear my name. After all we were at war, not taking a stroll in some national park. No one asked me to be here—it was of my own choice, therefore any complaint was both pointless and without substance.

I was asked to be at the ready for the following night's planned offensive by our brigade. However, the Germans anticipated us and we were fiercely attacked and engaged in a long battle that lasted until dawn. Our side fought stubbornly, at times even man-to-man with bayonets. The Greeks are at their best at this type of warfare, and the Germans paid dearly for it.

In the morning, the field facing the First Battalion was littered with German corpses, while our death toll was minimal.

18 Nickname given to Germans during the Second World War

This was followed, of course, by Tsakalotos' "daily orders," part of which I herewith reproduce:

> Zone of operations dated X IX 44 from Brigade Commander: I observed last night from the Command Station with Vice Commander and Adjutant to the Battalion Captain C. Lianis this second German offensive. I was greatly impressed and completely satisfied by the enthusiasm and composure displayed by our men, resulting in the cutting down to one third our losses and this, despite the man-to-man fighting etc.

Captain Lianis happened to have been, though dead at the time, the father of socialist Prime Minister Papandreou's second wife. Unfortunately, in an interview, his daughter proudly referred to him as the "Red Colonel," which couldn't be further from the truth—more especially in the case of an officer pertaining to Rimini's Third Brigade.

This book does not have any political attitude. Just so as to put the record straight, I consider it my duty to establish his reputation, and I also wish to mention that he played a part in my citation of valor and my promotion to the rank of Warrant Officer, by casting a positive vote on my behalf at the Promotion Committee.

JOUR FIXE[19]

The war in Italy was getting tougher by the day. After that ferocious night, the Greeks decided to wait no longer. In a surprise attack, without warning fire, they drove the Germans behind the fields into an inhabited area. Unfortunately for us the assailants this proved worse than expected. We had entered a zone where tens of farmhouses were scattered at intervals of five hundred meters from each other.

This layout offered the Germans a series of natural defenses that the Greeks had to seize with unequal courage, and at the great cost of at least four hundred wounded and dead. The space around each farmhouse had been turned into a deadly minefield. Each bush and dense footage was a hidden gun emplacement, each window a loophole, every roof a nest for snipers. Still, our worst enemies were the mines. In one single day, the brigade's corps engineers had disposed of five hundred mines.

Minesweeping devices could detect the metallic mines, but the German military geniuses had devised wooden mines that could not be spotted by conventional mine detectors, and so they wreaked havoc until they were found out. The diabolical German mind did not

19 *Fixed date*

stop there. One night, two Canadian patrols went out by jeep, and the following morning the drivers and co-drivers were found beheaded. Their bodies were still seated in their jeeps but their heads were ten meters away.

This is what had happened: They had been driving along a country road with tall trees on either side. The Germans knew we all let the jeep windscreens down to avoid being pinpointed by the reflection of artillery fire in the glass, both at night as well as in the daytime. So they measured the height of a jeep's seat and tied a thin steel wire across the road from one tree to another exactly at the height of the drivers' throats. At the speed they were going without windscreens their throats were sliced like a cucumber. After the first cases of this kind, a grooved iron angle, one and a half meters long, was screwed to the jeep's bumper to catch and cut these steel wires. Unfortunately, at war one comes across a number of treacherous weapons, and no amount of courage and bravery can face up to these. The Germans were good fighters but devious ones. When they were caught as prisoners, if a captor let down his guard, even for a split second, they would grab the gun from his belt and shoot him dead.

Meanwhile, the brigade, advancing slowly, captured one farmhouse after another, advancing slowly. The Greeks' favorite weapons were hand grenades and flamethrowers. They threw grenades in every opening—windows, chimneystacks, or skylights—and with the flamethrowers burned everything to the ground, including anyone inside the house. The fighting at the farmhouses against the barricaded Germans occurred every night and always ended with hand-to-hand struggles. This was not the sort of battle that lasted one, two, and three, or even five days, after which you held your new position until taking the next step. As a rule, during these operations, a reinforced platoon of thirty to forty men undertook the attack on a farmhouse. First came the reconnaissance of the surrounding field, then the clearing of a path from mines before the actual offensive. One such heroic local undertaking was the one of Lieutenant Korkas and his platoon.

Korkas was deployed in Casa Fanioni, which he had captured three days earlier with a platoon reinforced by men of various skills. It was the night of September 11 when he was ordered to advance five hundred meters to the north of Casa Fanioni toward Casa Monaldini. He set off carefully with his platoon through the field, crawling on many occasions to avoid any possible surprise attack and in fact managed to arrive undetected as near as thirty meters from that farmhouse. It was too late for the Germans to use their defense weapons in time, but they did manage to fire some shots and kill two of our soldiers who had not taken cover. The platoon was successful in accomplishing the first part of the operation by encircling the enemy inside the house; their strength and number, though, was unknown. At some point a German officer made a run for it with some of his men through the back door hoping to reach a trench in the field, but they were intercepted by Sergeant Tsatsakis with four of his men and were wiped out. It was then that the Germans counterattacked from inside, with hand grenades, machine guns, and flamethrowers, while our men stubbornly returned their fire. Dawn was breaking, and it was getting very dangerous and difficult to continue without being detected.

Meanwhile, Lieutenant Korkas had been wounded and bled profusely. By his side lay also, heavily wounded in the chest, his sergeant, a very brave man who had been fighting every night for weeks on end. Farther down, his corporal, thought hit in the leg, was still fighting.

Korkas shouted to him, "Go away, go back," but he would not listen until a hand grenade finished him off.

Now, in complete daylight, the Germans positioned in another farmhouse two hundred meters away joined in. Korkas and his men began to withdraw, carrying or dragging the wounded as best they could, both the stretcher-bearers having been killed. Two days later, when the brigade's main body, comprising of two battalions, attacked Casa Monaldini, the house was found deserted; Korkas's

platoon and twenty dead and injured had done a good job after all. It is also of interest to note that prior to the brigade's undertaking in that sector, a platoon of forty Canadians had attempted to capture Casa Monaldini, but no one had returned. In fact, when Korkas returned, the Canadian officers asked him if he had found any trace of these Canadians.

It is unnecessary for me to say, as facts speak for themselves, that our brigade heroically advanced toward the capture of its main objective—the town of Rimini. It advanced and gained the ground that both the Canadians and New Zealanders had failed to achieve despite their endeavors. The Greeks fought fiercely as if defending their own home ground, gaining the admiration of all the Allies.

Congratulations arrived daily from all sides, from General Paget, New Zealand's Freyberg and the commander of the Canadian forces, who personally came to congratulate us. This was all well and good—until the significant night of September 13, 1944. At nine in the evening, we were informed that one hour before midnight, a great campaign would be launched with Battalions One and Three, with the mission to take over the Batara-Maldoni-Monaldini-Monticeli line. This meant an offensive on a one-and-a-half-kilometer-wide front, which included four well-fortified points of defense like those four farmhouses that had held on for so long at the cost of many lives. First on the move was the Third Battalion, and at twelve-thirty, only one and a half hours later, the platoon under Cavalry Lieutenant Bourdakos reported having seized Batara. Bourdakos was en route toward Maldoni. Yiannopoulos's company was also advancing toward Maldoni. By two o'clock in the morning, the entire First Battalion attacked Monaldini and the village of Modiceli. This campaign had developed into a battle that lasted the whole of the following day, and the outcome was clearly on the side of our battalion.

Meanwhile, one hour before the offensive, around ten o'clock, a motorcyclist came from the Command station with orders for me to move ahead with Mac with two smaller cranes and await further in-

structions. At ten forty-five, I arrived as instructed and, having camouflaged the cranes under some big trees, awaited my new orders. Vangelis was in a good mood and said, "Tonight is a *jour fixe*." He explained why he knew what a *jour fixe* was, as he used to go to some joint in Piraeus harbor where, on a set day, a tenor named Denogia—God only knows where he dug up this tenor—sang. Denogia was born in Greece of Italian parents but could not speak a word of Italian. In fact he was more of a Greek than Vangelis was—yet when the Greco-Italian War broke up in 1940, he was thrown in a concentration camp as a dangerous Italian spy! A cock-and-bull story if ever there was one! Anyway, Vangelis went on insisting that we would have a good deal of *jour fixe* that night.

At precisely eleven o'clock, the mechanized vehicles set off, led by a jeep with two sublieutenants, followed by a few armored half-tracks transporting troops. Somewhere in the center of the column was the captain's jeep, escorted by two other officers, and behind it another five or six armored half-tracks also transporting fifteen to twenty soldiers each.

Now the last vehicles of every platoon came from all directions through the dirt roads, the fields having been safely cleared of mines due to so many comings and goings to and from the farmhouses. Suddenly, I saw that on a side column, the last armored car had choked up and would not start. At some point the driver succeeded in starting the engine, and his column had disappeared into the darkness. He could, of course, follow the preceding tire tracks and catch up with them, but instead, after advancing for fifty meters, he went off to the right.

Observing the shadowy mass, it was obvious to us that he was going in the wrong direction. Even Vangelis wondered, "Where is that fool going?" Before he could even finish his sentence, not one but two mines exploded in quick succession, illuminating the whole tragic scene.

"Here is the *jour fixe*," said Vangelis, jumping inside Mac.

I had already started the engine without waiting for any orders. The mere thought that at least twenty men and the officer were trapped in the minefield without any hope of getting out of there alive was more than enough for me. I signaled twice with a red searchlight placed high on the crane to let them know we had spotted them.

Having advanced about fifty meters on the dirt road, as much as I could make out in the dark, I saw a side road. How the driver of the armored car had seen that road was a real mystery. He had followed it for about sixty meters and, of course, fell into a minefield, as this was not a corridor we had cleared.

Now there were many problems to consider, the most serious one being how far off the Germans were from them. Had they been seen, and were the Germans waiting for them to get out of the armored car and mow them down? No one could answer these questions. I took the capstan's wire hawser with the hook at the end, and advanced very carefully, treading on their tracks. Vangelis stayed with the crane and with his hands helped unfold the capstan, so as to take some of the weight off me. It must have taken me at least half an hour to cross these sixty meters, for not only was I marking time, but I also had to take care that the cabling did not fall out of the track line and blow up a mine.

When I reached them, they were all frozen with fear and speechless. These types of armored cars were topless, so I jumped in. The sublieutenant, who was the coolest of them all, asked with some anxiety, "What can you do about it?"

"Let me go in front and have a look," I replied. "The tracks at the back are OK, and, if the front wheels are still there, I can tow it back on its own tracks."

They were all brave men, but if you are trapped inside a minefield without knowing how to get out and in addition could have the Germans arrive at any moment catching you like a bird in a cage, believe me, it is no joke!

I let myself hang from the bonnet and saw that one of the wheels was intact but the other had disintegrated, and its axle was touching the ground. I told the sublieutenant that I would try to pull them.

I turned to the driver, who leaned on his side and seemed asleep, and said, "Having done your blunder, at least wake up and hold the steering straight."

"What are you talking to this one for? He is dead," said the officer.

Bending down, I saw both his legs cut off from above the knees. He had bled to death within seconds. His vehicle did not have a single sandbag for protection.

He deserves his lot, I thought, and asked the officer to put someone else in his place who could hold the steering wheel straight.

"What if I get the men to leave one by one, treading on the same tracks you came on?"

"That is out of the question," I told him. "They are wearing hobnailed boots and will draw the magnetic mines; as a result, not even half of them will get out of here alive. Look at my boots—they are underlined with rubber."

I left, after having rigged the capstan. Vangelis, seeing me arrive, crossed himself.

"Thank God you have come back. I thought of you as a has-been."

These emotional outbursts got on my nerves. "You are talking a lot of bullshit. Go and put some wedges under the wheel so I can start pulling; those poor devils in there have turned to ghosts."

True enough, two minutes later, having blocked all of Mac's brakes, I began to pull. The Beast groaned, but slowly and surely, meter by meter, I was bringing them back. The armored car stuck solid though after the first thirty meters and hardly moved. I had no intention of unnecessarily burning the Beast's engine, so I stopped. The axle at the broken wheel, during the towing, had gone deep into the soil like a plough and would not budge. Instead of the armored

car coming out, it was dragging Mac in.

"Listen," I said, having thought it out. "Take the big hydraulic jack and come with me. We will lift the front of the vehicle up and put on the spare wheel. These wheels have no rims so they can go directly on the axle with the use of a wedge. Then we will come back and pull."

"OK," answered Vangelis, and I saw him bring down an enormous jack weighing at least forty kilos.

"Take care when going into the minefield with the weight you are carrying," I said. "Tread exactly in my footsteps." It was easy for him to follow me, as it was getting light, and he could see much better now. On the other hand, this was not such a good thing, as the Germans—we still had no idea how far away they were from us—would also be able to see us much better. We reached the armored car without any problem. Two or three soldiers leaned over and took the jack off Vangelis's shoulders. We both jumped inside the vehicle.

Anxiously, the soldiers kept on asking, "What will happen to us,

Sergeant? Will you be able to get us out of here?"

They were right, poor chaps. After being pinned down for three hours, no wonder they were eaten up with worry.

"It is all over," I told them. "In a little while, we will all be out of here." I was saying this without really believing it.

With Vangelis, we both got the spare wheel that was strapped on the bonnet, together with the jack, to the front of the armored car. We were now treading on virgin ground—there were no tracks here. Only God could decide our fate.

"All of you move to the back," I ordered, so that the front part could become lighter and enable the jack to heave it.

The poor chaps moved swiftly, piling one against the other. We managed to lift it rather easily. The blooming axle was dug half a meter deep in the ground and delaying us. We quickly pushed in the

spare wheel, hit it with a sledgehammer we found in the armored car, and hoped for the best.

Unfortunately, it was now daybreak, and we were not the only ones to have a clearer view of things. The noise of the hammer in the stillness sounded like gunfire. Suddenly, a burst of machine gun fire raked the right side of the armored car.

"Fall to the ground," shouted the sublieutenant, and they all did so.

It was all very well for them, but Vangelis and myself were on the outside, though luckily on the left-hand side. From the sound of the machine gun, it was obvious that the Germans were at best only two hundred meters away.

As we were finishing off our task, the sublieutenant leaned over to say, "We will not return their fire in the hope that they will assume that this is an abandoned broken-up vehicle hit by mines. Only, get on with it. Get out of here and tow us out."

This was a clever ploy on the part of the officer not to engage in a fight until he could get all his men out to safety. If I could manage to tow his vehicle for another thirty meters up to the dirt road then the men could get out, skirmish, and without difficulty return to their lines. Otherwise, it would only take a German mortar to burn us all alive like rats. I was still leaning over, placing a pin to secure the wheel, when Vangelis stood up to put the jack back in the vehicle, and at that very moment a single shot was heard. It was a sniper's bullet.

With an "Oh!" Vangelis fell to the ground next to me. My first reaction was "No," and again "No, it is not possible—not my Vangelis!"

I took him in my arms and held his head there.

"No," I kept on repeating. "I will take you back, and you will get well," and all the while I was getting covered in his blood.

He had a wound just above his heart and the bullet had come out on the other side leaving a hole as big as an orange. Vangelis was

looking at me with glassy, vacant eyes. "Hold on, Vangelis. Stay with me," I said, and he whispered, "This is it!" and shut his eyes. Such pain and despair I had never felt before in my life. I pressed my cheek against his forehead and cried. As familiar as I may have become with death, Vangelis was something entirely different. "Come on! Get on with it," said the sublieutenant in a commanding voice. Lifting my head, I looked up at him with such pain and rage in my eyes that he refrained from speaking to me again after that.

I laid Vangelis on the front seat and asked the driver helping me carry him to keep the steering wheel straight. I went to the back of the vehicle, following the tracks almost on all fours. Some bushes gave me cover on the side of the Germans; it was completely daylight and I was myself exposed to those terrible snipers.

I was shaking not out of fear but of shock, continually visualizing Vangelis. His last words rang in my ear: "This is it!"

The poor man had felt since the day before that his time was up, saying, "Tonight we will have a *jour fixe*."

It was his *jour fixe* he was talking about. Reaching the dirt road, I jumped inside Mac and slowly began bringing over, with the help of the capstan, the armored car with the twenty soldiers in it, and Vangelis. Luckily the vehicle freewheeled easily, thanks to the spare wheel placed by my poor Vangelis. The men got out at once, scattered, and slowly moved back to their lines. One way or another, they all showed their gratitude, and even the sublieutenant patted me on the back.

"Don't be distressed about your friend. Be proud that you saved twenty Greek soldiers," he said.

"I lost my best companion," I murmured. "That is war," he said, and left.

That is all I need now, I thought, to have this fresh bloom telling me what war is about. Troubled and upset, I shouted at him, not caring if he heard me, "Go to hell, you jerk, you miserable desk soldier!"

Yet this desk soldier sent in a report, recommending Vangelis for a posthumous medal for gallantry and myself to be promoted to the rank of Warrant Officer for bravery. Of course, I never became a Warrant Officer, as in the meantime we returned home and it all remained only on paper. As I have said before, this homeland named Greece has a very weak memory. Heroes as well as traitors are fast forgotten.

With the help of the two engineers, we laid Vangelis and the wretched driver responsible for our misfortunes inside Mac, and left for my unit. There waiting for me was Second Lieutenant N. Alexiou.

"Congratulations," he said clasping my hand.

"Congratulate him, not me," I said, showing Vangelis's lifeless body, tears running down my cheeks again. He called two soldiers on fatigue duty, and they dug a grave for Vangelis. This other legless body was sent to his unit.

After that, with a heavy heart, I gathered Vangelis's personal effects and sat writing a letter to his wife, Fotini. Of course, I was unable to send it at the time, as the Germans were still in Greece, but upon our return I had it all delivered personally to her by a soldier at the address on his identity card. She never came to see me, never wrote or called me. She never showed any interest in finding out how her husband had died or where he was buried. I couldn't help remembering how right my Vangelis had been when saying, "Some left Greece to escape from the Germans, others to fight, but I left to escape from Fotini!"

CROSSING THE RUBICON

On that night of September 13, the brigade's offensive was launched with the 151st and the Third Battalions, later to be joined by the Second Battalion, which showed the foreign armies of the Adriatic front how heroes fight. The Germans themselves, as our prisoners informed us, were saying, "Our officers could not understand the change at Monticeli and Monaldini and had to replace our infantry units with two parachute companies."

During an all-day battle and well into the night of September 14, the brigade took and mopped up the Maldoni-Monaldini-Monticeli-San Lorenzo line. I can but write of heroic deeds for that forty-eight-hour battle, but I do not wish to tire the reader by continually referring to these. I only wish to report that the first wave of assault of the Arbouzi Company attacked the German trenches at Monticeli in a hand-to-hand struggle. When at dawn the second wave of that same company attacked, all the Greek soldiers were found dead inside the trenches but under each dead Greek soldier lay a dead German pierced by a bayonet. Those were the Greeks of the 1940 generation.

Each dead man of the Arbouzi Company was awarded a posthumous medal for "Exceptional Deeds."

At that point, the road leading to Rimini Airport, which was

not too far from the town itself, should not have caused too many problems. The Third Battalion, to which the English had detached six Churchill-type tanks, charged first. All in all, the brigade possessed sixteen tanks of that type from the English. The only problem occurred when crossing the Marano River. The retreating Germans blew up, as was their tactic, all the bridges. There was not much water in that particular river, but the banks were rather steep, which was the reason why I was sent to join the Third Battalion at four o'clock in the afternoon and take up a position exactly behind the six tanks. At four thirty, the tanks took off, and, with no infantry support, eliminated the few pockets of resistance they came across on their way to the river. The Germans had retreated and had entrenched in the village of Tramondana and even farther back at the southern corner of the airport.

The first two tanks crossed over with some difficulty, for, as I said, the opposite bank of the river had a steep slope, and if the driver was not an experienced one, as was the case, the tank or any other vehicle that would follow risked rolling back and getting smashed. At this point, Captain Spiliopoulos, whose company would go first, ordered the crane to go over now, and, when it reached the other side, to have the winch ready to pull up any vehicle that could not make it. I engaged all three auxiliary gears, revved up the engine, and the beast was underway.

I had pinpointed where the water was no deeper than half a meter, and I went down into second gear, rather than first, as the weight of the beast could pull it to one side. Before reaching the water level, I hit the accelerator, crossed the riverbed at full speed and began to climb with the throttle fully open. I made it beautifully, and the soldiers on the other side, seeing the beast fly, clapped their hands roaring with laughter.

After that, the remaining four tanks followed. Two of them climbed over the other two, and I had to jet down the winch to untangle them and pull them up. Luckily, I found an enormous tree nearby, passed a thick chain around its trunk and tied Mac on it

to create a resistance. This way, with blocked brakes, thick wedges under each of the six wheels, plus the trunk, I was not in danger of being pulled down by a tank. Please note that the Churchill tanks weighed forty tons. Not even half of the remainder vehicles made it by themselves. By the time I brought up the last one it was midnight and I was completely exhausted. I told its driver that when we returned to Athens I would find him a job as a streetcar driver!

Immediately afterward, the battalion, with rested men, as they had had nothing to do since four o'clock in the afternoon, left in fighting trim on their way to seize Tramondana. I stayed five hundred meters behind and fell asleep. At four in the morning a motorcyclist arrived from the battalion, and here is the dialogue that followed:

"Wake up, Sergeant."

"Leave me alone; I'm tired."

"I know, but the commander has sent me."

"What's happened this time?"

"Come and get Nikoloudis's tank out from under the ruins."

"No matter. I will do it in the morning."

"But Nikoloudis is inside, as well as two gunners, and they will suffocate."

"How did they get themselves in this situation?"

"We took over half of the village but could advance no farther, as in the church's belfry about ten Germans were entrenched with mortars, machine guns, and snipers giving us the works. The sergeant gave the order to open fire and shoot down the belfry. Nikoloudis fired a single shot that only opened up a hole in the steeple, as it's strongly built. The gunner's second shot went astray, which infuriated Nikoloudis, who engaged the tank both in first and in auxiliary gear and drove it at high speed against the base of the steeple. It shook badly and came tumbling down, like a felled big tree. Half of it covered Nikoloudis and his tank, which could go neither forward nor backward. The battalion is in the process of trying to occupy the

other half of the village, and I was told to direct you in great haste to that church before they suffocate!"

While he talked, I was getting dressed, laughing away, as I knew Nikoloudis well and what a grouch he was, and I could imagine the curses and abuse he must have been hurling.

"Be quick about it, sir, for the steeples are giving us a real licking…"

I followed the motorcyclist with Mac. On the way, we cashed in a few bullets left behind by snipers, who could well have been Italian fascists still in action by the side of the Germans, but neither of us got hurt. We entered the village of Tramondana, which both the Germans and Greeks had ensured to be a heap of ruins.

When we reached the belfry's mass of rubble I kept on laughing, imagining Nikoloudis buried underneath it. The only thing I could think of was to get the Italian inhabitants, now gathered around, to remove the stones from the rear of the tank so that I could place a hook on it and pull. I gave a few knocks on the tank wall with an iron bar to let them know we had found them and had begun to tow.

As I did so, the corner stones started to fall off right, left, and center, the turret came into view and opened up, and out jumped a furious Nikoloudis. I tried to restrain myself from laughing again, knowing he would get furious, but the more I tried to, the more I laughed my head off.

"What are you laughing about, you idiot?" he asked. "I saved the entire brigade from the teeth of this belfry."

"And I saved you from your stupidity, you twerp," I answered, in a temper now.

Badly entangled, Nikoloudis left on the double to catch up with his battalion, which was trying to seize the southern corner of the airport. After some fierce fighting and many casualties, the forces of the First Battalion came as near as thirty meters to the road bordering the Rimini Airport. For two hours they were engaged in one of the worst battles against the Germans who were entrenched in the deep road ditch.

At the end of these two hours, the Germans began to withdraw. The Greeks pounced, crossed the road, jumped into the ditch, grabbed the German machine guns, turned them around, and fired at the withdrawing enemy. As a result, though they only found twenty-six dead Germans in the ditch, that number was really double. Among the dead were four officers. The first phase of the operation to seize the airport was over. The southeastern corner was now in the hands of the First Battalion.

This meant that no German plane could land or take off from the airstrip without becoming a sitting duck. The airport had become useless to them.

For this achievement, congratulatory telegrams fell like rain from the Canadian and New Zealand unit commanders. Only one pureblooded English unit, the Royal Dragoons, abstained. For two days they had been involved in skirmishes on one of the roads leading to the airport, and it was only when we had sent one of our companies to help out that they had managed to drive back the Germans. They had probably not appreciated this, as they had wished to be the first to enter the airport.

Coming from another side, the Third Battalion, with Apostolakis's Second Company as a vanguard, attacked the village of Cosalecchio, and within an hour had taken it, all except its church—yet another steeple here!—which had been turned into a stronghold, and where the Germans were putting up stout resistance. At once, three tanks were required from the New Zealanders, and at around six o'clock in the afternoon Cosalecchio was entirely mopped up. In that operation twenty-eight Germans of the First Parachute Division, considered the army's elite troops and fanatical warriors, were captured. Such was their fanaticism that one of the sublieutenants, when compelled to surrender to the Greeks, turned his gun to his temple and shot himself.

Tsakalotos sent the following telegram to the general chief of staff in Cairo:

> The 1st Battalion, crossing Marano River, have sped up its advance to Rimini's airport, seizing stronghold positions. It has captured ten automatic weapons. Four officers and fifty German soldiers dead. Thirty German prisoners taken with raised arms to the Command Post. These German raised arms represent submission to Greece in the battlefield.

At ten thirty on the following morning, the Second Battalion continued its advance and occupied the northwest side of the airport, meeting up with the First Battalion. Virtually the whole airport was now in the hands of the brigade, except for the north side where German parachutists wouldn't easily relinquish their positions. At eight o'clock in the evening of that same day, the Second Battalion advanced and also occupied the northeast side of the airport.

By nightfall the entire airport, as well as all the surrounding buildings, was in the hands of the First and Second Battalions. In fact, the brigade now occupied the entire line, comprised of the airport, the north bank of the River Rodella, up to the sea, but they still advanced without halting as, other than fighting the Germans, there was a speed contest underway with the Canadians as to who would enter Rimini first, which was only four kilometers away. Meanwhile, the brigade had issued the following order to all fighting battalions:

The Canadians are vying as to who will enter Rimini first. Rimini is the due reward for the Brigade's hard struggles. Continue to advance swiftly and steadfastly toward our objective.

It was Thursday, the twentieth of September 1944, and until noon the brigade was unable to advance. The German parachutists had decided to die rather than retreat. They were getting killed, wounded and decimated, and though they realized they could not hold their position for long, they stubbornly wouldn't move an inch. The situation seemed rather difficult, and to the eyes of our soldiers, the vision of taking Rimini had begun to get hazy.

Around four thirty in the afternoon, along with the vision, their

brains also blurred, and they went all out in a stormy, unrestrained assault. They fought with bayonets in hand, and after a terrible slaughter drove the Germans out of their trenches suffering many casualties, unfortunately on both sides. By the night of September 20, the road to Rimini was open for the Greeks. So, in the early hours of September 21—after twenty-four hours without sleep—at last Tsakalotos's long-awaited orders were issued:

> General offensive of all three Battalions against the town of Rimini.

The reaction of the men was unbelievable and indescribable. The units resembled racehorses in their starting boxes, ready to pounce forward at the sound of the bell. The mechanized vehicles, with running engines, impatiently awaited the *go* signal. The soldiers, holding with one hand a Tommy or Sten gun, or rifle and bayonet, and with the other a hand grenade, pin drawn, the finger on the tiny spring peg so it wouldn't explode, eagerly awaited their marching orders. I was attached to the Second Battalion right behind the armored cars, in case one got hit and it needed to be towed away to clear the road.

All three battalions advanced vigorously, overcoming many German pockets of resistance, comprised of determined parachutists left behind to set up traps and lay ambushes, which cost the brigade many lives. The moment of entering Rimini had arrived at last. The Second Battalion, holding a more advanced position, entered first, followed by the Gerakini Company, then the Papageorgiou Company.

In the town's main street, a German platoon, hidden in a building, attacked both battalions from the rear. Thirteen Germans were killed and nine captured. I don't know what happened to them, though I was nearby and could hear the commotion. I am sure, as one of our men wished to stay behind to turn them over, they must have left them in the ruins, unarmed for the Canadians.

After this incident, the Second Battalion advanced, and at eight

o'clock in the morning hoisted the Greek flag on Rimini's town hall. Before the Gerakini Company had arrived, two hundred meters from the town hall, a captain grabbed the flag from the hands of the soldier holding it, and, running through the rubble whilst bursts of fire could still be heard and stray bullets fell, he rushed up the stairs of the town hall and raised the flag on the balcony balustrade. This captain, named Mitropoulos, is still alive, and I can imagine how he must feel at the sight of today's Communist youths burning the Greek flag during riots.

In the meantime, the Third Battalion, coming from another side to a large square where a palace still stood, hoisted its own flag. The First Battalion, located on the bridge of the Tiber River, which flows through the town, hoisted its own flag across the arch from where Julius Caesar once addressed the Roman Legions after having crossed the Rubicon.

How could poor Julius Caesar have imagined that in our day not the Romans but the Greeks would cross the Rubicon, only in the opposite direction? His statue cut motionless and grim figure, haughtily inspecting the crowds. The soldiers of the First Battalion discovered him; they flung a black beret on his head and placed in his hand a bunch of withered flowers. With some paint they wrote in Italian under his statue:

Take these to Mussolini with the glad tidings that the Greeks took Rimini.

Mussolini was particularly fond of Rimini and had built a villa near Riccione. The Greeks on their way went in and gave it a good going over.

On another huge building was one of those ridiculous inscriptions they had filled Greece with, which read "Vinceremo."[20] The Greek soldiers wrote underneath, "We Vinceremo."

At seven thirty in the morning and prior to the First Battalion hoisting the flag on the town hall, the Italian Mayor of Rimini pre-

20 *We shall conquer*

sented himself—a little terror stricken—to Apostolakis's Battalion, stating that he was ready to surrender the town with every formality. Tired and half asleep, having been up all night, Apostolakis told him, "Get on with it; we are in a hurry." So without much talk, the following protocol for the surrender of the town was drawn out and signed by Apostolakis, the mayor, and the supposed town council:

> In Santa Maria de la Coronella, on this day Thursday the 21st Septem-ber 1944 (written in full) and at the hour of 7:30 the herewith undersigned Committee comprised of Bortoni Gombeno President, its members 1) Bortoni Romolo, 2) Del Prato Biaggio, the members of the Anti-Fascist Community for the liberation of this city and all others that have deserted it, have presented themselves to the leading Greek Forces i.e. the 2nd Company Commander of the III Battalion of the Greek Mountain Brigade, Captain Apostolakis Michael and hereby SURRENDER unconditionally the city of Rimini.
>
> We entrust the Greek Forces to keep law and order and protect the popula-tion with full discretionary powers.
>
> The present document has been drawn in the Greek, Italian and English languages and duly signed and delivered to the President of the Committee.
>
> In witness of this instrument drawn The Officer taking over the city
>
> The Surrendering Parties
>
> Apostolakis Michael Captain
>
> (signatures)

Apostolakis and his brigade were delayed—as was expected—by the jabbering of the Italian mayor, and as a result the Thomoglou

Brigade advanced outside Rimini with the mechanized Armored Personnel Carrier vehicles (APCs), in order to take over the Marrechia River. Due to our delay, the Germans had time enough to destroy all the river's bridges. Only one strip, not wider than a meter and a half, on one of the bridges was still standing.

When Captain Thomoglou and his APCs arrived, a New Zealand platoon attached to the First Battalion with twelve APCs was already there. The New Zealand major had already tried to get them across the riverbed, but the first two had got stuck in the mud. Then, one of our own warrant officers of the First Battalion, named Zographos, having carefully measured the width of the remaining strip and that of the APCs—despite the shouting protests of the New Zealand major—demolished the protective parapet an along the strip.

With this initiative, he gained forty centimeters of width. Now the caterpillars of the armored cars fit inside the strip exactly. First, he took across his own APC, driving it himself, of course. Then he went to the New Zealand major and took through his APCs, in front of the astonished eyes of the New Zealanders. All by himself, Zographos took to the other side of the bridge nine of our armored vehicles and ten of the New Zealanders'. It was later discovered that this strip was laid with mines on the sides where the caterpillars did not tread.

In the meantime, in the town of Rimini there remained some of our units, for technical reasons, as well as some military police to impose law and order. I was among them, clearing up the main street to enable the armies replacing us to get through. The strange thing was that no Italian civilian was to be seen or walked about. Not a single soul. We discovered the meaning of this much later from an inhabitant who came running out of the house, rushing to hide in another.

He admitted that all the residents were in hiding, or had left for the "refugee"[21] in the fields, as the German authorities and Mussolini's Italian followers had scared them off. They had told the people that the Greek armies were coming to town because although the

21 *Refuges*

Germans currently occupied their country, prior to that the Italians had occupied it, and out of revenge they would slaughter any inhabitant they would come across—well, well!

After these revelations, we offered him tins of food, beers, bread, and chocolates the Italians had not seen since the 1936 Ethiopian War.

"And the Greeks?" he asked. "When are they coming?"

We burst into laughter and clouted him on the head. "And what do you think we are? Indians?" asked one of our soldiers.

He completely lost it, poor chap. At once, word got around, and one by one the people came out of hiding.

The reading of the other congratulatory telegrams from King George II of Greece, Crown Prince Paul, and Prime Minister and War Lord George Papandreou followed this. I will quote George Papandreou's telegram, which I copied from the War Archives, so that those who later monopolized his name in order to reap ideological laurels may see the real laurels bestowed by G. Papandreou to the warriors of Rimini on the battlefields of war and honor:

> Order No. 1005 from the Prime Minister, Cairo.
>
> We are all deeply moved by the successful actions of the Brigade on the battlefield by the side of the Allies, You kept your word. You revived the Albanian Epic. The glory of Rimini crowns your heads. In the name of your Hellenic Homeland, we thank you and bestow your flags with the order of the Distinction for Bravery.
>
> Long live the warriors of Rimini. Long live eternal Greece.
>
> George Papandreou
>
> Prime Minister

George Papandreou was fully aware of the importance of the brigade's victory. He had already expressed the opinion that it was "a historical turning point." With this victory in his briefcase, he met Winston Churchill in Naples, Italy, on October 8, 1944, and claimed the territorial integrity of Greece. The "integrity" was especially important, for a month earlier, on September 8, Stalin founded the miniature State of Macedonia (Scopia), with the aim of penetrating into our own Macedonia, partitioning Greece and acquiring for the Soviet Union an outlet to the Mediterranean.

Up until this time, Churchill was already of a mind to yield Greece to the Russians, as after the liberation the Russian-motivated EAM communist organization prevailed almost entirely in this country.

The Churchill-Papandreou meeting changed the destiny of Greece. Papandreou had the faculty of oratory and being a skillful communicator convinced Churchill that Greece had every potential to exist outside the Soviet bloc and that the brigade, aided by the English, could restore law and order in the land.

At the famous Yalta Conference, with Roosevelt and Stalin, Churchill had scribbled at the back of his cigar box, "English 90 percent—Soviets 10 percent." This is why I get overwrought when right-wingers ignorantly inveigh against George Papandreou—as prime minister of the government, he managed to keep Greece in the free world.

The brigade was built up by conservative men who did not take part in the Middle East mutinies and the dispersal of the First and Second Brigades. The Conservative party owes a great deal to the brigade and their man, for it is only thanks to them that it was able to govern the country for over thirty years after the war.

And now, a few words about the Right-Wing Party:

In 1944, fifty years after the Battle of Rimini, on the site of the Riccione Greek cemetery, there gathered representatives of all the countries whose armies took part in the battles of the Adriatic: Ca-

nadians, New Zealanders, English, Poles, Hindus, as well as Italian officers who considered the Greeks as having freed them from the Germans in Rimini. High-ranking officers represented Greece from the chief of staff, by the flags of the three heroic battalions of the brigade, by today's colonel and commander of Rimini's Brigade, a unit that is always in "honorary" existence in the Greek army, and some aged veterans.

Andreas Papandreou's socialist government was represented by his foreign minister and younger officials, as well as by a wreath from the prime minister and the president of the republic. I have to mention all the above, for on behalf of the Right-Wing Party not a single member of parliament, nor a single wreath was sent for the hundreds of dead left behind in Rimini, who enabled the existence of a conservative party in Greece

Going back to the war itself, after the ceremony for the surrender of Rimini, under the sound of gunfire and mortar explosions from all three battalions fighting one kilometer north of Rimini, we left to join our units.

War continued relentlessly, full of spite and death. Rimini cost the brigade the lives of six officers and seventy-one other ranks, while nineteen officers and 175 other ranks were wounded.

CIGARETTES AND PERFUMES

The war of numbers continued to rise. One thousand meters from Rimini, the battle went on late into the night. After the occupation of Rimini, the men were completely exhausted and were entitled to some rest. With this in mind, at dawn the orders issued by the commander of the First Canadian Division, General Vox, were for the brigade to withdraw from the front line and to be in reserve between Rimini and Miramare. The men handed over to the New Zealanders with great relief. The replacement was made swiftly and without problems, though the Germans were in the habit of watching our every move from observation posts and always attacked at such times.

Miramare was a magical site by the sea, and the luxurious beach of the Rimini Palace Hotel was almost intact. I managed to hide Mac in the hotel gardens by camouflaging it well. I entered the hotel and got hold of a room on the second floor, but alas it had no bathroom! I found out that Antoni, the turner of the garage repair shop, had requisitioned the room next door to mine, which did have a bathroom.

"Come on, Antoni. The bathroom is of no use to you; you haven't bathed since before the war, so take my room and I will take yours," I offered him.

"Whatever you say, Sergeant, sir," he replied. "Just as I was asking myself what the hell is this wash house doing next to my room…"

I asked the men working the crane to nail some sheets of hardboard on the windows, as there were no panes left. There was no hot water, but there was running water! Apparently we hadn't done a good job with the town's water reservoir; it must have escaped our attention. So I had a cold bath, which didn't matter much as it was still summer, used up at least two bars of Palmolive soap so generously handed out by mother England, and went to bed. Of course, there were no sheets but downstairs in a cupboard by the reception I had found some Italian flags made out of a first-class material resembling silk. I got hold of two and made up my bed with them. For blankets, we had plenty of our own. I slept like a log for several days and nights. My men brought food to me from the unit's kitchen.

After three or four days, I had recovered and felt as strong as an ox. I then went downstairs. It was a wonderful hot day, and the sun was burning, so I walked to the beach where all the soldiers lay on the sand sunbathing. No one, of course, was in the water. They all came from different islands, and as is well known only one out of fifty islanders knows how to swim. As a rule they do not even enter the water and fish only from trawl boats.

I took off my trousers, and in my white military trunks, under everyone's flabbergasted looks, went into the water. As I went farther into the still clean Adriatic Sea, I heard one of the men shouting at me from the shore.

"You, Sergeant, sir, risk a shark!"

Such was the mentality of people who had lived all their lives by the sea. As I was enjoying my swim, floating on my back, I was thinking of all the wonderful things in life and how lucky I was to have escaped up until now to enjoy them. Those who profess that life has no value in wartime are mistaken. Quite the opposite—it is most valuable then, for what you enjoy today, tomorrow may no longer be.

I came out of the sea to dry on the sand, and to the idiot who, so to speak, humored me, I said, "You will not get it either from a bullet nor from a shark, as you neither fight nor swim."

He felt the venom but had to keep his mouth shut and not talk back to me, for he was a plain soldier and I was a sergeant.

When I returned to the hotel, I came face to face with two chaps I was in El Alamein with.

"Come on," they said. "Let's go for a ride. We want to show you some houses down by the shore."

"What houses are you talking about? Has something been left standing?"

"No, no," said one of them. "There is a house built on a rock by the sea. You will lose it when you see it, I tell you."

"Let's go," I said, "but looting is out of the question. You will not touch a thing. No opening of cupboards and taps, no putting on lights."

Of course, every possibility had crossed my mind. If, as they said, it was such a fantastic house that had not been bombed, how could the Germans have left it without booby-trapping it? As I have mentioned before, I had a great experience with these toys in the desert, and I knew that the Germans left nothing behind that was not a death trap.

We got into the jeep, as one of the boys was Captain Thomoglou's driver. And as was the case the drivers use the jeeps more often than the Captains. We took the coastal road and then turned north.

"If you continue in this direction, we will soon be able to ask the Germans for the name and address of this house." After a while he turned right and we entered an estate through wrecked huge iron gates. Suddenly at the end of a tree-lined path appeared a beautiful house by the sea.

"Hey, you," I said, "You mean that in this house were Germans

who left it untouched for us to come and loot it? This is a volcano ready to erupt."

"What are you talking about, Sergeant, sir?" he asked, opening the front door for us to enter.

Truly, this was a very beautiful house, with good quality furniture. Yet there was something about it I didn't like. I kept silent, not wishing to appear scared. As I was carefully looking around, I heard one of the soldiers from an adjacent room saying, "I say, there is a grand piano here." Before I could shout "don't touch it" a horrific noise burst our eardrums, and then the debris came crashing down. What I was afraid of had happened. As soon as he touched the first key, the piano blew up bringing the whole room down. God only knows the amount of dynamite they had put inside the piano for such a disaster to occur. We found almost nothing of poor Manthos the soldier. His mate collected a few pieces that he placed in a bag and took back to his unit. The Germans were determined warriors and the worst snakes in the grass.

The loss of Manthos had badly shaken me, and I went straight in to see our captain, a splendid and learned man: "Please issue an order, Captain, sir, forbidding our men to enter houses. They are all booby-trapped!"

"I will issue such an order," said this good man with a hidden smile, "but you know the Greeks. They have pilfering in their blood—it is a sort of national sport."

The following day the captain told me, "Yesterday afternoon I went inland for a small stroll and saw from afar a farmhouse with a smoking chimney, and later a lamp was lit. Take my jeep and three or four men, you know how to pick them, and go and see what is going on there. Take good care. You are not a beginner." The love and trust placed in me by this man was unbelievable. He considered me the most capable, the bravest, and the most reliable noncommissioned officer in the brigade.

I left with four of the most callous and bloodthirsty soldiers in my unit, who I knew well from El Alamein. I only trusted El Alamein soldiers; the rest I considered desk soldiers.

We arrived near that farmhouse and hid the jeep in some bushes fifty meters farther away. Suddenly the farmhouse door opened and out came a little old man with extended arms shouting, "Amici greci" (Greek friends). I understood I had to deal with a peaceful man but was as always beware of traps. I told one of the soldiers to go and take a look around the house, and with one of the other soldiers approaching the old man still shouting, "Amici greci venite" (Come Greek friends), we all entered the house. To my great surprise, we heard a female voice saying in Greek, "Hello, soldiers!" She was obviously his wife, around sixty years old, and as she told me, they once lived on the island of Rhodes, which was how she knew a little Greek.

It was noon, and the woman offered to kill a *gallina* (chicken) and cook it for us all to eat. Of course we had not eaten home-cooked food since the days in Beirut. We accepted, and Nikoloudis, the tank driver buried under the steeple, offered to kill the chicken and did so with great pleasure. We had a wonderful meal during which the old man didn't stop talking of Rhodes. When lunch was over we thanked them and gave the old man as many cigarettes as we had on us, but he seemed very eager to tell me something. At one point he took me aside and holding my arm led me to a barn near the house. "*Vieni a vedere*" (come and see), he said. When we entered the barn he began shifting some large packs of hay and slowly from under it all appeared a small Topolino Fiat car as good as new. The old man explained that he had hidden the car because the Germans took every car they found. Then he came out with it: "*Dieci scatole di cigarette inglese, dieci scatole di savone, e ancora bacon e confitura, e lei prendi la Fiat in Grecia.*" The man wanted ten cartons of English cigarettes, ten bars of soap they hadn't seen in years, a few tins of bacon and marmalade and "take the Fiat to Greece!" Our trucks were full of provisions, but how could I take the car to Greece? I laughed

and told him I would think about it and come back tomorrow, "*vengo domani*".

On our return I went to report to the Captain, "As far as Germans are concerned we drew a blank. Not a single one to be seen," and went on telling him the rest of the story. "Go and get it tomorrow" and, so as to be at peace with his military conscience, added: "War booty. Put it inside Mac's coach department wherever it fits," and went on: "Have you got the ten cigarette cartons you need? Here, take two. I don't smoke, you can repay me by letting me have the car for a drive in Athens." I laughed, delighted with this wonderful man. In the meantime, I had to get together all the things the old man required from me. In the car I had four Craven A cartons plus the two from the Captain to make six. I also got hold of five or six boxes of Players, those round tin boxes with fifty cigarettes in each and found two Woodbine cartons, which not even the prisoners smoked, but the old man wouldn't know the difference. The chaps working the crane had a case of Palmolive soap bars that was of no use to them. They didn't seem very clean to me anyway. These two probably hadn't washed since World War I. "We keep them for some girlfriend, Sergeant Sir." I took about thirty bars from them and now all that was left for me to find was the bacon and jam. I went straight to the kitchen and found Angelo the cook who was my own man. "Angelo, give me a few tins of bacon, and five or six marmalades." "OK for the bacon," he said, "but what do you need all that marmalade for? Have you by any chance turned into a sissy, Sergeant Sir?" "Go to hell Angelo, I need it for my lay. Bring me the tins; I have the lay waiting in a house down by the fields." "Be on the lookout, Sir, lest a mine eats you before you eat the jam with your lay." I took the goods and left a happy man. The ransom had been taken care of and tomorrow I could "abduct" the Topolino.

Next morning I began the preparations. I took along with me Mac's two "engineers" and told them my secret. I further stipulated that if they let the cat get out of the bag and word got around I would send them pronto back to the infantry, to the Battalions, to the jaws

of Death. We got Mac out of the hotel garden and took the road leading to the farmhouse. As we approached we saw the old man lying on a low stone wall basking in the sun. As soon as he heard my beast approach he got up, knowing that the deal was clinched. "*Buon giorno amici greci,*" he shouted. We said hello and I asked the boys to bring over the goods. At the sight of the cigarettes, the soap, the bacon and jam his blood pressure rose and he almost flipped with joy. I had also added two army bread loafs. "Ma que bello panetone," the old man kept repeating. They were still eating bread made of roughage. He then started calling out to his wife: "*Rosina, vieni vedere*". More shrieks of delight from her.

Finally, we all went towards the barn, opened the double doors, pulled the stacks of hay and the Fiat was revealed. She was dark blue with red wheel rims and an open top. I had a look and saw that she was in good enough shape and had done forty thousand kilometres, which was not bad.

The only thing missing was the battery we had plenty of at the repair shop. If poor Vangelis were alive, he would have commented, "You've done well for yourself, securing a nice taxicab for Athens." Vangelis did not know that there were vehicles other than trucks, trailers, and taxis in Athens.

We all helped to push the little car out of the barn, though it was as light as a feather, and parked it near the beast. Having placed two nets under it, the crane lifted it as if it were a little bird. It fitted easily in Mac's coach without impeding the crane's movement. I was now the proud owner of a car for my nocturnal outings in Athens. This is where my thoughts wandered, but then I checked my daydreams and said to myself, "First let me remain a leftover from this feast and in one piece, and then I will see what happens in Athens."

Back in Rimini, I hid Mac once again in the hotel gardens and went to get my captain. As soon as he saw the car he went into deep thought.

"It is OK," he said. "But give your two men a brush and paint

to camouflage it in the unit's colors." He continued, "In its present state, it reminds one of looting, but if you paint it over, it will become war booty."

"And how long will I go around Athens in a camouflaged car?" I asked him.

"For as long as the said car has the sign H. A." showing in front, you will keep it camouflaged. When you get proper number plates you can paint it blue again."

"At your orders, sir," I told him, as there was nothing more to say.

The next day, my men, hidden inside Mac, painted the Topolino a deep green shade, added some shadows, and it turned out just fine. They also placed at the front a plate with an H. A. and asked me what number to put next to it.

"Put your Athens phone number."

"I have no telephone, Sergeant, sir."

"Then put…When were you born, Basil?"

"In 1918, Sergeant, sir."

"That's it!"

So, the Topolino became H. A. 1918, and we let the military police work out where the other 1917 vehicles were.

When the week of the rest ended exactly on September 26, the order was issued by the Second New Zealand Division of our brigade to replace the Twenty-Fourth New Zealand Regiment all along the River Uzo.[23] The replacement was effected during the night of September 26. In fact, by nine thirty in the evening, the New Zealanders had already departed. The order to cross the Rubicon was delivered to the First Battalion, which, assisted by the Second and Third Companies, crossed it successfully.

22 *Hellenic Army*
23 *Today's name for the Rubicon*

This is different from Julius Caesar, who hesitated two thousand years ago, and, when he finally overcame his hesitations and ordered his legions to cross it, said the famous words: *jacta allea est* (the dice has been cast).

After the crossing of the Rubicon, the First Battalion was further ordered to advance on Bellaria, a powerfully well-organized German stronghold. At midnight then, in spite of all their endeavors, the battalion was pinned down. The Germans had decided to defend themselves to the last. With fierce machine-gunning and the use of another diabolical weapon, the six-shooter mortar, its strange shells exploding and shattering in innumerable fragments with destructive results over a one-kilometer radius, the First Battalion was forced into a defensive position all night, suffering many casualties.

The following day the First Battalion went all out into a new offensive but was literally drowned in mud. The torrential rain, since the early hours of the morning, had transformed the fields into swamps, and all the wheeled vehicles as well as the armored cars got stuck. Needless to say that the entire recovery unit, with first and foremost my Mac being the best machine there, worked all night facing the Germans, whose artillery never stopped pounding, to extract from the mud the tens of immobilized vehicles.

Meanwhile, a cable arrived from the New Zealanders addressed to the commander of the First Battalion:

New Zealand armored cars report that soldiers of 1st Brigade as well as Infantrymen of the Recovery unit are exposing themselves unnecessarily during the offensive. They are brave but please order them to walk and work undercover. Dead or wounded cannot beat the enemy.

>Commander of the 5th New Zealand Brigade
>General Hopkins

At once Tsakalotos dispatched the following brief order:

I repeat, we are few but, stop any senseless behaviour, act with prudent bravery.

Colonel Th. Tsakalotos,

Commander III Hellenic Brigade

That terrible night, when I was up to my waist in slime, trying with the help of another sergeant to extract a huge forty-ton Churchill tank, I heard the said sergeant by my side, saying indignantly, "It is still the twenty-eighth of September, almost summer—how can it be raining like this?"

"Wait a minute," I said. "The twenty-eighth of September is my birthday. I was born on this very day."

"Why don't you shout aloud then?" came the reply. "What should I shout for?"

"Shout, 'Mama, why did you give birth to me?'"

At that very moment a shell passed near us. Its whistling pierced our eardrums.

"I don't know why she gave birth to me, but now she almost buried me."

The next day, in a surprise attack, the First Battalion advanced, repelling the German defenses, which had to retreat for eight kilometers back to their lines, and occupied Bellaria. Of course, these dashing attacks have their cost. This one cost us two officers dead and three wounded, four soldiers dead and fifteen wounded.

Unfortunately, from this point the Germans had a very well-organized defense line the Greeks were unable to break and, as it was raining relentlessly, none of the mechanized vehicles could take part in an all-out effort. Even the men out on night patrols during small skirmishes were knee high in the mud. After one such skirmish, they returned with six German prisoners…but they proved not to be German after all. They were of a Turkish tribe and had enlisted in

the German army when inside Russia, not because they sympathized with the Germans but out of hatred for the Bolsheviks, who can turn a human reaction on its head!

One day had gone by since the capture of Bellaria, and the Greeks were literally stuck in the mud. On October 3, the First Battalion withdrew south of Bellaria for a rest and was replaced by the Third Battalion, but on October 9, the First Battalion returned again to the front line to replace the Third Battalion, while the Second Battalion stayed put. This immobility, endless replacements, the rains, inundations, and mud, plus the cold, which had begun to be felt—this was the north of Italy after all—combined with continuous sleeplessness, had the soldiers on edge by now. It is well known that the Greeks cannot stay in one place; backward or forward, but never still.

So, as if by heavenly providence, on October 13 came the news over Bari's radio station at six thirty in the afternoon Italian time that the Germans had withdrawn and Athens was liberated. What went on after that at the brigade's units is hard to describe. High emotions, tears, joy, wild enthusiasm, singing, shouting, you name it. Sheer pandemonium.

Athens was free after four years! When the recovery unit corporal came running to give me the news, my thoughts went straight to my home, and my eyes clouded over against my will. Soon, at long last, I would return, and I wondered if they were all well. Of course, there would always hang over our home the black shadow of the loss of my brother-in-law, the wonderful man and hero I wrote about in an earlier chapter. As I visualized my mother, I suddenly thought, be prudent and for as long as you still have to fight, leave the bravado—someone must return home alive.

At once Tsakalotos requested the authorization from the "A" Canadian Army Corps for all guns of the brigade's artillery to fire twenty-one salvos (with real shells, of course) to salute the liberation of Athens. This philhellenic Canadian general who was full of admiration for us, issued the order for all the guns, five hundred in

number, of the Canadian Army Corps to also fire twenty-one salvos. So at eight forty-five, on the night of October 13, four hundred guns announced to the Germans by a terrible drumfire that the Acropolis was rid of the Nazi flag, which for four years profaned its sacred rock. Of course, the Germans facing us were unaware of the reason for this terrible bombardment. I suppose they found out later—at least the ones that survived the "Liberation of Athens" by five hundred cannonballs twenty-one times over!

In the meantime the fighting continued and, as ordered by the "A" Canadian Army Corps we always kept "in defense order," as per the military code. For four days we remained in the same position, and in this order, night and day rejected the German attacks, which was more difficult than an offensive followed by an approach formation. The bad weather combined with the German attacks had tired and exhausted our men, especially as they expected from day to day to be replaced and at long last go home.

Luckily, that day was not too far away. On October 17, the order for the replacement of all three battalions was issued. On that same day the military police was ordered to make a reconnaissance of the Bellaria-Jesi route. The day for the departure of the brigade for Greece had come. On October 18, the brigade convoy was formed. "For us the war was over." These were great words!

As we departed very early in the morning, when outside Bellaria, I said to myself, "Thank you to the Lord that I am a leftover!"

I was once again at the very end of this long convoy. After no more than an hour, the convoy came to a full stop. The head of the column had reached Riccione right in front of the Greek cemetery. I climbed down from Mac and went in search of the recovery unit's second lieutenant.

"Let's go and find out what is going on."

I got in his jeep, and we drove to the head of the column. Awaiting us was a sight I will never forget as long as I live. More than

one thousand soldiers and officers on their knees were following a memorial service, led by the brigade's priests, facing the amphitheater-shaped Rimini graveyard. That is correct, the entire brigade was on their knees paying tribute to their dead comrades who would not have the good fortune to return to their homes. They would remain here, facing Greece and listening to the waves coming from the shores of their homeland. Men as tall as trees, unshaven, sleepless, exhausted, who had fought and suffered many hardships but with heads high and chests full of medals, these men couldn't hold back their tears. This image would remain indelibly printed in my memory.

When the memorial service was over, the brigade continued on the road of return. We marched down to the coast past Pezaro, Fano, and Senegalia, and before reaching Ancona turned in toward Jesi to an English camp. The English were looking on as if we were ghosts. They appeared to me rather namby-pamby, with their freshly ironed uniforms and clean-shaven faces, but they were polite enough and tried their best to look after us. The following morning we left early after a fantastic English breakfast consisting of porridge, butter, marmalade, and more.

We took the coastal road past Ancona, Loreto, Cibanova, and San Benedetto, and reached Porto d'Ascoli, a lovely little fishing village where we camped all along its shore for the night. Basically we went on a lovely excursion…with good company and lots of cars. After all, we deserved a little break from Germans and bombs! We continued our voyage south, passing through large towns like Pescara, Vasto, Foggia, and Bari and stopped after ten days on October 27, ten kilometers outside Taranto. We camped under a large pine tree forest ideal for a rest. We were to wait there until the ships taking us to Greece arrived.

Anyway, the following day was the twenty-eighth of October,[24] which quite rightly we celebrated with every splendor. For the Greek army to be on Italian soil on such a date was odd, but also very flat-

24 October 28, 1940 is a national holiday commemorating when Greece said "No" to Mussolini and fought the Italians off the Greek soil. See Albanian Epic.

tering. For the Greek equivalent of the Te Deum came to our camp, along with many Royal Navy officers from the port of Taranto, as their ships based in Alexandria were patrolling the Mediterranean Sea.

I came across Sublieutenant Andreas Kouroussopoulos, who served, I think, on corvette *Sachtouris* at the time. As soon as he saw me, he shook his head with a look of despair and said, "You poor so and so, are you fighting here as well?"

No wonder he uttered these words. He had first met me in Alexandria on my return from Tobruk. He saw me again there when coming from El Alamein, and now I was here in Rimini.

"Let it be," I answered. "Just tell me how long you are in Taranto for, so that I can come over in the evening and hit the town a little, as I am going around the bend after all my solitary wanderings…"

"I think we will be here for a couple of days, but come down to the ship around seven and we will see where we go from there."

After the evening parade, which also meant the mess call, we were allowed to go out until the six in the morning parade. As for myself, as I had been promoted in Rimini to the rank of sergeant major, I could leave any time I chose.

I took a jeep, one of those brought in for repair, and left at about six o'clock for Taranto. I sent word of my arrival to my friend through the sailor on duty by the ship's gangway. He came down, sat by my side in the jeep, and started to talk.

"Listen to me," he said, "Let me tell you a few things, as you will be staying here for a while, so that you can learn your way around. The Italian women sell their souls and their bodies for a pair of silk stockings. In Italy, all you can find are some thick woolen ones. Not even in your wildest dreams can you find silk ones here. We manage to bring lots of them over from Alexandria, and as a result lead a glorious life." I was all ears, getting educated. He went on: "Only be careful. The Italian women are sly. So, first give only one stocking, then go out on your date, and if you get what you want only then do

you give the other one. But take care, for they are capable of snatching the stockings and running off."

I listened in silence.

"Furthermore, French perfume is in great demand with the ladies, as well as face powder, brilliantine, and so on."

"And where will I find all these goods, Andrea?"

"Now look, I am leaving in two days' time. I still have some stockings and a few other things, but in exchange I want you to find me a German pistol."

I jumped with joy at the thought that I would get the silk stockings off Andrea, as in my crane I housed an entire arsenal.

"My dear Andrea, say no more, armament-wise. I have a full house. I have English arms, I have a variety of German ones from prisoners or deceased; I even have a Parabellum, a Walter, and another make I cannot remember." The deal was clinched. Tomorrow night I would give him the Walter in exchange for five pairs of stockings, two lousy French perfumes by the names of "Soir de Paris" and a "Pompeia" brilliantine.

As for tonight, Andrea would treat the lady of my choice to a pair of stockings. This did not prove difficult as Taranto was a port, ships were coming and going, Allied troops were in the vicinity, and the Italian ladies had taken to the streets to secure their daily bread: a pair of stockings, a bar of soap, some English cigarettes. Such degradation of the female species I had never come across, and God only knows the ports I have visited and the joints of every description in many lands!

We had fun with Andrea, and I returned to camp at dawn.

The following evening I went down to Taranto and gave him the Walter, along with thirty bullets as a bonus, and took delivery of the five pairs of stockings, two patchouli perfumes that not even the gypsies of Paris would use, as well as the brilliantine, and we said our

good-byes. He was officer of the watch, and they were off at three in the morning on patrol on their way to Alexandria.

I had a steady group of three or four companions at the camp, all known members of the Alexandria elite circle, the most aristocratic being Fokas, who had been mobilized there and due to their education were all sergeant majors and serving in desk jobs.

So at night we went out usually all together in Taranto, as our friendship dated back to my days in Beirut. In fact, at my wedding with the French woman, the General's daughter, they constituted the groom's guard of honor. Needless to say that I had completely forgotten, during all the war trials and sufferings, my "wife" Simone. I had received a couple of letters from her in which she wrote, "I learn from Daddy of your whereabouts and where you are fighting, and I pray to God for you to get killed as a punishment for having deserted me in this manner, in a cinema, so as to leave with those *sales Grecs*."[25]

Now what am I supposed to answer to a woman who professes to love me but prays for my death so that I can be punished and she can be justified? I have had enough problems at the front with mines, bazookas, and guns to have on top of it Simone praying to God for my death. Lucky for me I wasn't killed, with all the odds stacked against me, in addition to Simone's pleas.

So what was I to answer? So sorry I wasn't killed? I forgot all about her, and that was the end of it.

25 *Dirty Greeks*

ATHENA'S HEAD

So, in Taranto I went out with the Alexandria group but said not a word to them about silk stockings and the rest of it…

One day my captain said to me, "I want the brigade to acquire a medal depicting Athena's head surrounded by a laurel wreath and somewhere on the side the initials of the Third Hellenic Mountain Brigade."

Out of his drawer, he handed me a sketch done by two infantry men "artists" of the smokeless-gun types, sitting at their desks. We named them "roof tiles," as they were always sheltered inside a building or under a roof. I told him I did not think these could be manufactured in Taranto, but we might be able to find out where it could be done.

"And how many of these do we need, Captain, sir?"

"Three-and-a-half thousand," came the answer. "As many as our men."

"The dead will get one, too?" I asked, offering some black humor.

"Those will get gold-plated ones, so make sure you get killed as well," he said, returning my humor.

The following morning, I left by jeep for Taranto to make inquiries as to where I could place an order for three-and-a-half thou-

sand heads of Athena. Very wisely, I went to the *carabinieri* (police). There, only Vittorio de Sica, the film director, could have shot the scene that took place between the chief carabinieri and myself.

As soon as I entered the police station, the bowing began. It was followed by good mornings and "viva Inglese." On the second floor, they were brasher; they asked for "cigarette Inglese." On the third floor was the *commandante*.

When I walked into his office, his telephone and pencils fell from his hands, his chair flew from under him, and he rushed to my side, ready to embrace me, but I put a stop to that.

"Calm down," I said and sat him back in his chair.

I offered him an English cigarette; he threw at me another "viva Inglese," and I began in my poor Italian to explain my problem. He answered in English so as to please me, believing that opposite him sat the most blue-blooded Englishman, maybe even a relative of the British Royal family. Only, he was not speaking in English but in Italian, served with an English accent. Still, he was very happy being face to face with a true blue subject of His Majesty, the King of England.

What he told me, though, was not completely irrelevant. As the problem concerned medals he would send me here in Taranto to the agent of the Italian State Mint.

"What sort of medal is it? What does it look like?" he wanted to know.

I took out of my pocket the sketch and showed it to him. He looked at it thoughtfully, for most probably Athena reminded him of a Roman lady.

"Questa signiorina inglese?" (Is this an English young lady?) "Greca," I answered.

His blood pressure and pulse must have rocketed sky high as he turned red, then white, and finally his face asked me if I was Greek, and as he slowly recovered, realizing I had not slaughtered him, he stuttered a "bella Grecia," with a strained smile.

I got up to leave, as I did not wish to have on my conscience any mishap to his health incurred by my visit. We said our friendly good-byes while he was bowing and ordered a carabinieri with a Napoleonic hat to show me to the mint bureau, which surely I could not have found on my own.

We arrived in front of a state building, not far from the port, and he offered to take me upstairs and explain more or less what I wanted. A clerk took us to an office occupied by two girls. The one whose desk was nearer to the door looked like an ordinary civil servant, but the one behind her at the other desk looked like Sophia Loren must have looked at the age of twenty-five. I couldn't take my eyes off her, and suddenly I was blissfully happy before even having said *buongiorno* to her. As I neared her desk I felt dizzy just by looking at her. The clerk introduced me: "Il signore e de l'armata greca." (The gentleman is from the Greek army.) Now, I thought, she will pass out, having in front of her one of those Greeks that slaughter... but miracles of miracles, as soon as she heard the word Greek she practically embraced me.

She got up, shook my hand, said, "Molto piacere" (pleased to meet you), and immediately asked if I wanted something to drink.

"Cafe c'è?" I asked, and she answered, "Cafe c'è, savone non c'è," which meant coffee we have, soap we don't have. She said it so charmingly that we both laughed. She was a miracle, an Italian *miracolo*!

I then asked her how come she was not afraid of Greeks like all the other Italians.

"They are silly all the other Italians," she answered. "I know the Greeks well, and I love them."

She explained that her father was an Italian air force group captain and was in Greece. When Italy capitulated, and the Germans captured all the Italians, a Greek family hid him for almost a year, and he was then able to flee to Corfu and from there cross over to

Italy in a Greek *caique*.[26]

Though unfortunate enough to always find myself in the middle of flames and bam boums, I was very lucky to fall on girls like Yuki in Alexandria, Simone in Beirut—though she wished me dead—and now this creature in Taranto. Of course, I didn't know where this would lead, but already things seemed to be looking up. I hoped she would pay me back for all the good things the Greeks did to her father.

After the "reconnaissance" conversations were over, we came to the subject of Athena. She told me she would give a ring to the head office in Rome, propose the job to them, and inquire how they can do it and for when. She kept the sketch in order to send it to Rome and asked me to go by the following day at noon to give me further news.

I don't know how it slipped my tongue, but I said what I felt.

"And I will not see you until tomorrow at noon?" She seemed to like my reaction and I went on. "Which is the best trattoria[27] in Taranto for good pasta?" I added with a very sad expression on my face, "I have only eaten tin food for the last six months."

That did it. With a smile, she asked me to go by her house at eight o'clock as her father would be very pleased to meet me and afterward would take me to a good pasta restaurant. She explained how I would get to her house—fortunately it was easy—and gave me her name and telephone number.

Gabriella di Sant Angelo…From her name alone I understood that she belonged to a family of the Italian aristocracy. I returned to camp full of excitement and reported to my captain all about Athena. He was satisfied with my progress, but I didn't say a word to him concerning Gabriella. He knew my weakness for the fair sex and could have worried about the possibility of me bringing back medals

26 *Fishing boat*
27 *Restaurant*

depicting Gabriella's face instead of Athena's!

Gabriella, of course, had nothing in common with the girls my friends and I "socialized" with. From what she told me she had graduated from the Rome Art School and was an engraver. Because her family came from Taranto and had always lived here, her father had arranged for her to be appointed at this department of the State Mint.

At exactly eight o'clock in the evening I was outside via Garibaldi 11. It was a lovely villa almost by the sea but away from the port itself and on the way to Leece. I carried with me all the necessary supplies. A pair of silk stockings, which of course I would give her both beforehand, as I had to deal with a different quality girl and as in the morning she made that joke about the "savone," I took from the British canteen a box with twelve bars of Palmolive soaps. I had also brought along two cartons of Players cigarettes for her father as well as some roses from a florist. I did not wish to appear on her doorstep only with the merchandise, looking like a Greek tallyman.

I rang the bell and a maidservant in a freshly ironed apron answered the door saying with a big smile, "Buonasera, signiore." She led me to a sitting room full of antique furniture and large paintings on the walls. Gabriella came in after a while, wearing a Chanel suit—a civil servant in a Chanel suit, I thought to myself, and asked me what I would like to drink. I asked for a whisky, which Rosina (that was the name of the maid) served me. Gabriella took the roses and placed them in a vase—a perfect hostess—for when you are offered flowers you do not give them to a servant to arrange—it is insulting—and then came and sat next to me on the settee. As you see, I learned everything there was to know in record time.

I opened the package and first gave her the box with the soaps.

When she opened it she almost had a heart attack. "Savone!" she shouted, almost jumping to the ceiling with joy. She kept smelling them over and over again. Then came the big moment when I gave her the stockings.

As soon as she saw them she said, "No!" and almost fainted on the sofa. She then got up, caught me by the neck, and gave me a kiss on the cheek.

Nowadays, if you took soap and stockings to the girl you are courting she would throw them at your face and march you out the door. In the war years it was a different story. When for almost five years you haven't seen a single bar of soap, not only you do not throw the man out, but you worship the ground he treads on. Mind you, it was an orgy of exploitation against deprived people we took full advantage of, so as to have joyful days and nights.

"Why did you bring cigarettes as well? I don't smoke," she said.

"These are for your father to thank him for teaching you to love the Greeks…"

At that moment, a handsome type of a man, tall with white hair, very well groomed and very aristocratic looking, walked in the room. I got up, and we greeted each other. He told me he knew a lot about the brigade and warmly congratulated me, saying we were viewed as liberators in the town we took over from the Germans. I offered him the cigarettes he raved about, and I am sure that if I had asked him there and then for Gabriella's hand in marriage he would have given us his blessing.

The first evening with this fantastic girl was dreamlike. Other than being educated, clever, and pleasant, she was at least 175 centimeters tall, beautiful and with a gorgeous figure. We talked and talked and talked of many things and arranged for me to go back to her office the following day. Because I had also talked to her of my friends from Alexandria, she told me she was hosting a party on Saturday at her home and that I should bring them along to meet nice and beautiful girls instead of going around with street pick-ups. In other words, I got accommodated as to how to accommodate the rest of my military family.

Back at camp that night, I woke all four of them to announce

that I had fixed them up and that they should get busy washing and ironing shirts and uniforms, because the day after tomorrow we had a big party to go to.

"We are invited by Group Captain di Sant Angelo's daughter Gabriella, whom I am in love with and will probably marry!"

Focas jumped up, furious.

"Have you forgotten that we married you off in Beirut to the general's daughter?"

Another of my friends added, "In Beirut, he married the general's daughter. Here, he will marry the group captain's daughter, and when we get to Athens he will marry an admiral's daughter so as to cover all three fighting services."

I told them they were unfeeling brutes with no idea what love was all about and that had it not been for my caring they would end up with street whores. And on that note we went to bed. The next morning I also did a little washing up, including those two Italian flags I used for sheets, which I had pinched from Rimini's Grand Hotel. At noon I went to Gabriella's office. The news was as follows: The medals could be produced in Rome exactly as we wanted them and within the reasonable time of twenty days, but an authorized officer from the brigade had to sign the order form, make a down payment, and all the rest of it.

My brain worked like lightning. I would go to Rome, take Gabriella with me, and have a ball. This is more or less how it all worked out except that my captain was putting pressure on me and wanted me to leave at once for Rome. But I had to go to a party. After all, I told him, it was a weekend, and all the services in Rome would be shut. So it was finally decided, to my relief, that we would leave with Second Lieutenant Alexiou by jeep early on Monday morning. As Gabriella could not ride with us in a military jeep she would catch the train and join us at noon in Rome. Meanwhile the Alexandria quarter was still washing and ironing on Saturday morning, but of

course as I was free to come and go to Taranto with my own jeep, thanks to Athena, and had given my clothes to be ironed at the dry cleaners.

At exactly seven o'clock on Saturday, everyone was ready with military precision as if we were leaving for the front on a war mission. I let Focas drive the jeep, as I did not wish to get creased. We stopped in a pretty little bar and had a drink so as not to be the first to arrive at the party—and completely sober at that. We arrived outside via Garibaldi 11 at nine o'clock and the Alexandrians gaped at the sight of the beautiful house surrounded by palm trees and cypress trees.

More mistrustful than the rest, Focas inquired, "Are you sure that we are invited here at this palazzo?"

I looked at him with disdain and rang the bell. Rosina opened the door, giving me a warm welcome. I turned to Focas, who was recovering after having witnessed the welcome, and gave him the eye, meaning, "As you can see, I hold a position here."

We were ushered in a small sitting room and greeted there by Gabriella, who wished to put everyone at ease and kissed me on the cheek. This gesture broke the ice, and at last Focas was convinced that we were truly invited in this Palazzo. I introduced one by one the quartet to Gabriella and knew she had won them over by the look of greed and admiration on their faces. We exchanged a few words and moved on to a larger sitting room where about twenty guests of every age but obviously of the same background were being entertained. Among them were some good-looking girls; Gabriella must have invited them as company for my friends. She made the necessary introductions and I somehow felt I was the guest of honor, for she was showing me off to everybody as if I was her betrothed.

Focas, in the meantime, had monopolized the best-looking girl and talked to her incessantly. He was a master in small talk. The evening went by very well, though I was a little apprehensive in case the Alexandrians got too drunk and we were all in for some indecorous behavior. But as I said before, they had a good upbringing, so their

behavior was irreproachable. First, Gabriella pointed out that it was dawn and we better get back to camp. We were in no position to work out if it was day or night.

After the usual good-bye, I'll be seeing you, thank you, and fixing dates with the girls, we hopped in the jeep, which I drove, as Focas was very much in love and I didn't trust him. We arrived deliriously happy and smiling at the camp and slept like logs due to the amount of alcohol we had gulped down.

I had made all the arrangements with Gabriella, who was due to leave on Sunday noon by train and would be staying with her cousin, Countess Joanna Ruspoli. Upon my arrival, I would give her a call so that we could get together.

Very early on Monday morning, around six o'clock, we left by jeep with my Second Lieutenant Alexiou for Rome. The trip was dreamlike. The road was in good condition, those left from the Italian army were repairing the destroyed bridges, and there was not much traffic except for military cars. Leaving Taranto behind we passed the Apenine mountain range on its southern side, the towns Matera, Potenza, Emboli, and we arrived at Salerno where Eisenhower's army made the big landing and where the war remnants were more than apparent on both sides of the road: burned-out vehicles and tanks as well as isolated graves here and there with white crosses.

Leaving Naples on our left and passing Caserta, we took the Naples-Rome *autostrada*—though one could no longer recognize it as such—and came near famous Montecassino where for three months the Americans sacrificed the cream of their armies before occupying it. From then onward not one single house was left standing or a single tree for that matter. The soil had been dug up by gun shells for hundreds of square kilometers.

It was almost noon, and we were almost in Rome. I had been driving for six hours nonstop. Before arriving to our final destination in a pretty village called Frascati, I stopped outside a little coffee house to Alexiou's great surprise.

"What has happened to you?"

"Not what has happened to me," I answered. "Coffee or I fall asleep here and now. Not even the Pakistani soldiers put in such a day's work."

We drank our cappuccinos, my eyes opened again, and we got in the jeep to continue our journey. As Alexiou got in the car, he saw at the back all the merchandise I needed in order to live like a human being in Rome. I had a case of cigarette cartons, another one full of soaps and jams, and a sack filled with clothes, as well as the stockings and perfumes.

"What are these?" he inquired, a little bit annoyed.

"Without these, you will not even see God's face in Rome."

"We have so much money with us, what do we need these for?" insisted the Second Lieutenant. "The Italians also have money; it is soap, cigarettes, and chocolates they don't have. So if you want to have a good time, leave it to me."

Alexiou burst out laughing, and we were on our way.

After half an hour we reached Rome, and with the help of the map I had on me I found the via Veneto where the brigade through the British Garrison Headquarters had booked two rooms for us at the hotel Albergo di Commercia, which was not that great. Still, after sleeping on a flimsy mattress inside Mac, the bed at the Commercio felt like a Napoleonic couch.

After a quick shower and a change of clothes, I called Gabriella.

On the phone came the *contessa*, her cousin. She asked me if I was the "Signiore Greco" who she had heard so much about from Gabriella, said she wanted to meet me, and then handed me over to her cousin. I began to realize that with Gabriella's favorable introductions I was getting along well in Rome's aristocratic circles.

Gabriella sounded very pleased that I had arrived without a hitch and informed me that she had already been to the mint offices, had

given them the sketch of Athena's head, and had made an appointment for ten o'clock the next morning for us to go and sign the order form and wrap things up.

We arranged our date for the evening, and I went down to the restaurant to have a dish of spaghetti. As per my sacred rule, I then went back upstairs for a siesta while Alexiou, as per the petit bourgeois sacred rule, went for a stroll in town. I spoke to him of our appointment and said that he should be precisely at nine thirty in the morning downstairs in the hotel lobby ready for us to leave. I did this in good time because I intended to disappear for the night.

And sure enough Gabriella came to get me in the evening from the hotel, and I disappeared. Of course she knew Rome like the back of her hand. First we went to a nice trattoria at Trastevere for dinner, and then she took me to a fantastic nightclub. Later in life, whenever in Rome I went there to revel. The name of that nightclub was Hostaria dell' Orso.

It was something between an inn and a luxurious horse stable. There was a bar downstairs with comfortable settees and a grand piano played by a wonderful pianist. Upstairs was the restaurant, orchestra, and dancing. We sat downstairs at a table next to the piano. Having already drunk a bottle and a half of wine at the trattoria, I ordered a bottle of prewar champagne, Veuve Cliquot, which of course costed a bomb, but I didn't care as I was loaded after all these months on the front. Besides, I was in the throes of happiness after all my hardships. It is a wonder, though, how quickly I could find my old self again! Watching Gabriella by my side looking ecstatically at me and obviously in love, I remembered the Russian prince, my friend Alik, who used to say, "You drink like a Russian, revel like a prince, and have the temper of a legionary."

I suppose the same thoughts must have crossed Gabriella's mind. She looked stupendous that night, wearing a tight black dress with a deep, plunging neckline and a double string of pearls. Needless to say, everyone at the bar was gaping at her, especially because she

purposely let her dress lift up, displaying the silk stockings I had given her and that she was so proud of. "I have some more pairs at the hotel," I told her…

Later we went upstairs and danced to a couple of slows of that period when suddenly the orchestra played "The Man I Love." Oh, my God, I thought, Yuki's ghost, and I remembered her with some nostalgia but quickly shut my mind off, for were I to go down memory lane I would need to start an anniversary book to remember them all.

I had no idea what time we left, nor did I care. Of course, Gabriella came and slept at my hotel. Fortunately, being the more responsible one, she gave me a jolt around nine in the morning. Otherwise, nothing would have woken me up. After a great effort on my part we went downstairs to meet my second lieutenant. I don't know what the appearance of someone having a heart attack is like, but Alexiou's face betrayed an oncoming severe heart failure.

The man had assumed, when I informed him in Taranto that a young lady working at the mint would come with us in Rome, that I was referring to some poor little civil servant coming to assist with the transactions. Upon seeing by my side a 1.75-meter-tall beauty whom I introduced as Countess di Sant Angelo and who—to crown it all—came out of my room having spent the night with me, his little bourgeois heart couldn't take it. He uttered a "how do you do" and fell silent. Thank God Gabriella had brought a raincoat with her and had covered herself up in it. Imagine if he had seen her in her black dress with half her bosom showing and had died of a heart attack—what a problem I would face having to write to his family in Greece that he was killed in action on the battlefield!

Anyway we went to the medal department at the state mint, where Gabriella had seen to all the arrangements. We signed, paid, and left.

Alexiou said to me, once outside in the street, "Let's go to the hotel and get ready to leave today."

We were standing on the pavement when I shouted in such a loud voice that the Romans turned around curiously looking at me, "Are you crazy or something?" I asked him furiously. "Because I had everything solved and we finished in record time we must now fall all over ourselves and leave at once so as to put on a 'good boys' act for the captain?" I added, "I'm not going anywhere."

Of course, the poor chap had been bored stiff since yesterday and wanted to leave. "We are staying here for one and two and three days as it is doubtful if by yourself without Gabriella's and my help you would have finished the job in less time."

Alexiou, seeing my rage, did not speak. Gabriella watched and listened, unable to understand how I could speak in this tone of voice to a second lieutenant. Well, when for over three years you fight side by side with a man you can speak to him as you wish; you acquire that license.

"Hear me out," I said in a calmer voice. "Tonight, with Gabriella's cousin Joanna Ruspoli, we are going to the theater to see an Italian review that is a big hit. Then we will go out to dinner, and you will see what a good time we will have."

As soon as he heard the word "cousin," Alexiou calmed down. I explained to Gabriella what my tiff with him was all about, and as we had already talked of these plans with her the day before, she gave him a reassuring smile and all was well again.

We left by jeep, and I dropped him somewhere near the Piazza d'Espagna to have a look at the shops, which by the way were practically empty of any merchandise and went with Gabriella to the theater to get the tickets. Gabriella said it would be very difficult to find some seats, so I grabbed a carton of Lucky Strike cigarettes from the back of the car and told her, "Let's go to the ticket desk together."

She very politely asked the cashier, "May I have four seats for tonight please?"

With a grim face, and without even looking at her, he said, "Not

tonight, not tomorrow, not the following Tuesday."

Then, with a grim look as well, I thumped the cigarette carton on the cash desk, pushed it in and said to him, "Quatro biglietti per stasera."[28]

He lifted his eyes, looked at me, saw my uniform, took the cigarettes, issued the four tickets—third row, if you please. I gave him 40,000 lire and left. Gabriella was still standing there thunderstruck.

I waited for her in the jeep. She suddenly burst out laughing and joined me. It was noon by now. I was hungry and still suffered from last night's hang over. So we went to have a good spaghetti lunch and drank a bottle of Lacrime Christi[29] as I am a firm believer in homeopathy. Drinking can only be cured by more drinking! I drove Gabriella to the Ruspoli Palazzo in Parioli, Rome's best neighborhood and returned a real wreck to the hotel for a good night's sleep.

28 *Four tickets for tonight*
29 *Christ's Tears, a Venusian Italian wine*

IN ATHENS AT LAST

We arranged to meet outside the theater at eight o'clock as too many goings and comings with girls in a military jeep could prove dangerous. All I needed to have my stay spoiled was for a "picket," one of those British military policemen, wearing a red kepi to apprehend me.

We waited for five minutes with Alexiou for the girls to arrive by taxi. The cousin was a great looker as well—tall with black hair and a fair complexion. We made the introductions. I don't think Alexiou had ever escorted a more beautiful date. He wasn't bad looking himself: fair, around twenty-seven years old, very polite, and he spoke English. The cousin, though, was constantly looking at me as if inspecting me and kept turning and saying something to Gabriella that I could neither hear nor understand.

We sat in our very good seats—what wonders some cigarettes can accomplish in Italy—and the curtains rose. It was a typical revue similar to the Greek ones, in the good old days. At the Teatro Picolo, that was the name of the theater, a comedian named Nino Tarando, at the peak of his fame, made the audience fall about with laughter. I couldn't catch the jokes of course, but Gabriella tried her best to explain some of them. The jokes were based on the situation

the Italians were in, washing without soap, smoking cigarette butts thrown away by the English, and so on. Afterward Tarando took his curtain call to wild applause, and a musical program followed. I was overcome with surprise and a strange emotion when I saw a young girl, microphone in hand, standing in the middle of the stage. At first I was uncertain but then sure that this girl was Luisa Poseli.

The last time I saw her was in the summer of 1939 when she came up to Kifissia to perform with Attik.[30] She was a sensational artist and Attik's last great love. So "Poselaki," as she was affectionately called by the whole of Athens, was singing American and Italian songs here. When at the end of her performance I shouted from the audience, "Sing 'The Poppy,'" she was taken aback and leaned over to see who I was. She greeted me and asked the pianist to accompany her as the orchestra had never heard this song before. Poselaki sang "The Poppy," and at the last refrain tears were running from her eyes. Needless to say, mine did the same—to Gabriella's great surprise, for she only knew me as a merrymaker and cold-hearted warrior.

I went backstage to thank her, and her eyes were still wet. "You are going back to where I lived and loved. Alas, Greece is a closed chapter for me, just a memory, as things have turned out thanks to the Italians."

Luisa was an Italian who, if I am not mistaken, was born in Greece. Her father was an Italian musician living in Athens at the time the Greco-Italian War was declared. She was interned when the Italians in 1941 entered Greece aided by the Germans; she left for Italy never to come back again. Attik wrote his most beautiful and tender songs for her, his last great love.

As I was leaving her dressing room, she said, "If the master is still alive, when you return to Athens, tell him I have never forgotten him and whatever I am doing today owe it to him. He taught me everything."

30 *A famous, talented songwriter and musician*

Unfortunately, I was never able to give him that message. A few months before my return, Attik was dead. Some say he committed suicide, unable to bear the shame he felt after two Germans hit him and left him for dead on the pavement one night when he was walking home after a performance.

It took me a while to recover emotionally from this encounter, but by the time we reached the cousin-countess's home, I was my old self again. The interior of the house was really palatial. Huge sitting rooms, each piece of furniture a work of art placed with the renowned Italian good taste. We had a drink and then went into the dining room. Luckily all four of us sat on one side of the table; otherwise we would have needed a telephone to help us communicate from one end of the table to the other. By my calculation it could sit thirty-six guests.

The cousin, so it appeared, had her ways and means with occasional suppliers or merchants of the black market, for she lived off the fat of the land. We had prawns as a first course, filets for the second, desert, and more. The wines were picked from her own cellars—a white Moselle for the prawns, a red Bordeaux Mouton Rothschild for the meat, and a Laurent Perrier 1938 champagne for the dessert. If Italian countesses don't know how to entertain, then who could? The one, of course, who had no idea was Alexiou, and when I explained all this to him he was dazzled. In fact, at the end of that evening I tactfully sent him off to bed at the hotel as I intended to spend the night at the Palazzo with Gabriella at my side.

In the morning—so as to be correct—I gave Gabriella the stockings, one pair for her and one for the cousin, who was still asleep. As I was leaving, Gabriella told me, "When Joanna gets up and I give her the stockings, she will faint and fall on her bed again."

I arrived by taxi at the hotel where the second lieutenant was anxiously waiting for me. As soon as he saw me he said, "Listen to me, we haven't fought for four years, tossing up our lives to end up returning to Athens in handcuffs being court-martialed as deserters.

It is all over; we are going back."

"You took the words out of my mouth," I answered to cut him short and lighten up the atmosphere. He had taken the whole thing very seriously. "We will collect our belongings; you will pay the hotel bill…"

"I already have," he said.

"Good, then let's go and say good-bye to the girls and leave."

This is more or less what took place. At the cousin's palazzo, we emptied the jeep of cigarettes, chocolates, soaps, and whatever else we had while the girls laughed their heads off, saying, "Do you think we are going to open a grocery shop?"

But I am sure, after we left, they got in a bath tub with all the Palmolive soaps and got out of it the following day. Anyway, as I was taking my leave I told the cousin that I would invite her to Greece for my wedding with Gabriella, and Alexiou who was at my wedding in Beirut was muttering in Greek, "Promises, promises, what have you got to lose…"

On our way back we laughed a lot and had great fun with Alexiou as our business had gone well and we had enjoyed ourselves.

"By the way, if Gabriella comes to Greece, and Simone chases you to land on your doorstep at the same time, what will you do?" he asked, a little worried.

"I will have a mass wedding like the ones given once a year by Papastratos[31] for his factory girls."

Back at camp we reported to our captain that the mission had been accomplished. He congratulated Alexiou, who had done absolutely nothing, saying to him, "Bravo that you were able to see it through and at such speed."

"You see?" I told him, indignant for pestering me to rush back.

Anyway, the Rome trip was behind us, and life went on at the

31 *Cigarette magnate manufacturer*

camp. And it did go on until twenty days later the order was issued for the main body of the brigade that was the three infantry battalions to get underway. The rest of us remained behind. I couldn't understand why and was in such depths of despair that my low spirits annoyed Gabriella.

"Now, wait a minute," she said to me one day. "Don't I play any part in your life?"

What was I supposed to answer?

Of course, those of us who, like Focas and I, had entered into a relationship went to Taranto in the evening, but no one was in a good mood. This waiting was a trial on everyone's nerves, and that included the one thousand officers and soldiers at the camp. We had grown fed up with Taranto and the Italians all around us. A characteristic example of this annoyance is the following: We were having dinner one night at the restaurant Four Seasons, and a few tables away from us a group of soldiers belonging to the artillery (not from the upper drawer may I add) seemed a little tipsy.

At one point one of them told the waiter in Greek "get me water." The Italian waiter did not understand what the word *nero*[32] meant, and he went back to the kitchen. When he returned the soldier caught him by the collar and said to him again in Greek, "Didn't I ask you for water? Where is it?"

The Italian kept saying, "Ma non capisco."[33]

So then someone in the group showed him the water jug, upon which the poor chap tried to get away from the soldier's grip and said "Ah, acqua!"[34]

That ass of a soldier thought that the waiter was making fun of him and shouted, "You heard it, you son of a bitch, and didn't bring it," and clouted him on the head.

32 *Water in Greek*
33 *But I don't understand*
34 *This sounds like "I heard" in Greek*

Of course, the general situation was to blame. The soldiers could no longer stand the Italians and wished to go home, but in all honesty, I have to say, the Greek army in Italy, which in point of fact was an occupation army, was not a model of good behavior. There were instances we should not be proud of, but those were only isolated cases.

The exasperating waiting brought us to December 1944. A strange activity prevailed at the camp. Some were saying that the ships taking us home had arrived at Taranto, others that all leaves had been suspended, and we were leaving in the morning. Yet none of it seemed to be near the truth. So I decided to go and see my captain.

"Tell me, Captain, sir, we are all parched by anxiety for over a month now. Especially because I come from Athens, the feeling that Athens has been liberated from the Germans for two months now and that my mother expects my return and here I am just sitting around waiting and doing nothing is more than I can bear. Tell me please what is going on and when we are leaving." The captain, who was a reasonable and exact man and knew whom he could confide in, said, "First of all, have you written home?"

"I did."

"Then your mother knows you are alive. Now listen carefully. There are all sorts of events going on in Greece, something resembling the mutiny we experienced in Egypt, only this is on a much larger scale. The ELAS[35] army and its leaders control almost the whole country with the exception of some areas. Two days ago they have encircled Athens with the aim to prevail in the capital. Prime Minister George Papandreou agreed last month with Churchill here in Naples that Greece will remain under English influence as opposed to Soviet, which is the case for the rest of the Balkan countries. Stalin has also agreed to it. Therefore ELAS does not have the backing of Russia. Foreigners respect agreements; Greeks don't. So ELAS, a

35 *Greek Popular Resistance Corps, originally a communist resistance movement against the Germans*

communist-oriented army will fight to take over Athens even without Russian approval and support."

I murmured, "This means civil war." And then I asked, "And what forces are available in Athens, Captain, sir?"

"Three brigade battalions, a police force, a gendarmerie regiment two British 'airborne' regiments, those with the red berets, and a small armored company with Grant and Churchill tanks. Keep it under your hat until tomorrow, but we are leaving in two days."

I couldn't believe my ears. The dream of returning to Greece was turning into a nightmare. Returning to Greece meant peacetime, the end of the war. It meant seeing our folk, the mothers we could hardly remember other than as images on the wrinkled photographs we had carried for four years in our pockets. It followed us in the minefields, heard the whistling of bombshells, and almost melted in the furnace of the desert. We were about to speak at last with our mothers themselves rather than communing with pictures and now this dream was falling apart and we would be at war once more.

No, this is not possible, I told myself. I am not fighting in another war, and in a war of attrition at that. You fight for your country, you fight maybe to extend it, yes, but a war of ideas is unacceptable on either side. One can respect the ideology and point of view of a person but should not support a war for their ideas. What does one achieve other than the ruin of one's country? This is exactly what happened to Greece. Instead of sitting at the victory table to vindicate our rights we were killing one another in a war of ideas.

We abandoned our claim on the north of Epirus that we had fought tooth and nail for during the terrible winter of 1940, leaving behind thousands of dead and burying thousands of cut-off frostbitten legs. We abandoned that land for the passion of fighting one another.

The conversation with my captain and all these thoughts kept me awake all night, and despair had pushed to the limits my mental

endurance. I drank a glass of whiskey and a second one, then took the jeep and drove to Gabriella's house. While having more drinks, I told her all about it. I cannot believe nor understand that you are going to war again. You have fought in the worst battles during this disastrous war, and now you have to fight in your own hometown to enable you to go to your house and find your family?" I asked rhetorically. "If they are still alive..." I added. It was almost dawn. We had talked and drunk a lot. Gabriella could sense that the time of our parting had come. She did not stop crying, that lovely creature who truly loved me, and I never saw her again. I said good-bye to her, and when with clouded eyes I promised that after it was all over I would come back for her, I believed it; it was she who didn't. She was crying like a child at the door of her beautiful house as the jeep drove off in the morning mist. If I ever write another book, its title will be *War Partings*, for these separations have a particular feeling of their own. Sadness is combined with fear, an inner pride with a lot of pain—the pain brought about by the knowledge of finality for it is a final farewell.

The following morning the order was issued: Tonight we load the mechanized vehicles, and tomorrow we sail for Piraeus. We broke camp at noon and reached the port around four o'clock and the loading got at once underway. Unfortunately, they were liberty ships without hatches, so each vehicle had to be placed on a net hoisted by a winch and then put deep down in a hold.

First went the tanks because they were heavier, and immediately after was my beast, inside of which was my little Topolino that I had camouflaged with nets and other junk like ropes and oilcloths so as not to be detected by the English who could create problems. I waited until all the other cranes under my jurisdiction were loaded, then went to hold number one put at the disposal of the noncommissioned officers, laid my blankets down in a corner, and went up on deck. I was gazing at the town, trying to pinpoint Gabriella's house when Focas came to my side, leaning on the bulwark.

"Well, Alec, have you got yourself engaged?" I asked him. "No, but I will be coming back."

"So will I," and we looked deep in each other's eyes. We never cleared up if we meant what we said on that last day in Italy.

Focas, as soon as he was discharged a year later, left for Venezuela where he married a German princess, and he lives there to this day. I returned a couple of years later to Italy but did not go to Taranto. From Bari I drove up the Adriatic coast by car on the same itinerary as during the war. I went to the Riccione Cemetery and found one by one the graves of my friends and comrades-in-arms. I left some flowers on the tomb of my dear co-driver Vangelis, whose life was so unfairly cut short by a stray bullet. I also returned to Rimini fifty years later on September 2, 1994. I went over with a television crew to film a documentary on the Battle of Rimini. There were representatives and survivors present from all the armies that fought there—Canadians, New Zealanders, Poles, Hindus, and many active or retired generals. They all laid many wreaths in honor of their Greek comrades who fell in action for their country.

At dawn the ship left the dock of Taranto. I was wide awake on deck, sipping a cup of coffee that had been offered by an American member of the crew and remembering that eight months ago we had landed here in Italy wondering anxiously where the Germans would suddenly appear from and throw us back to sea. Thank God all that was over and I was one of the lucky ones returning home. That thought brought on the next questions: What is happening there, what will we come up against, what sort of warfare will we deal with, and, most important, how will I get to my house? This 1940 generation was truly a tragic one. Half of our life was spent at war or in political upheavals. It had begun when I was only ten, with Metaxa's dictatorship, his youth organizations and labor units, then Albania, the German occupation, the Middle East, Italy, and now this!

The trip lasted for three days. We had to sail around the Peloponnese because the Germans had thrown train wagons in the Corinth

Isthmus and blocked the passage. These three days, instead of being days of joyous anticipation, were spent in dark thoughts. I don't remember feeling that nervous even when going to Tobruk, though I was a greenhorn then. It was seven o'clock in the evening at the end of that third day when our ship entered the port of Piraeus. At some point I managed to discern the mass of the Naval Cadet School building also in complete darkness. Piraeus had the appearance of a necropolis, not a soul in the streets, and all one could hear was some far-away guns shooting. Some soldiers, probably English ones, were on the pier, which made the boat fast. In low spirits we flung ourselves into the task of getting the vehicles out of the holds as quickly as possible. In record time, by midnight, the ship had been unloaded.

When we disembarked, we faced no serious problem in the port area. After all, one thousand war-experienced men would not leave the ship and vehicles unprotected. So in a huge convoy we set off for Athens. In front of me were motorcycles of the British military police, and behind me—as I was coming last yet again—were two red kepi motorcyclists. I thought the whole thing was a bit of a joke, me being escorted by Englishmen from Piraeus to Athens, lest I get lost!

Anyway, at the head of the convoy rolled the tanks, placed there for any eventuality by the British. They were followed by diverse mechanized vehicles, then came the artillery, a carrier company, trucks, cranes, a Churchill tank, and last but not least myself, with a broken-down tank on Mac's platform. We took a right turn and slowly proceeded up the avenue toward Athens. No Greek military men were to be seen along the route, only English ones. Despite the firing, which was getting heavier as we approached the city center, we came under no attack. Of course after the battles we had been in, these rifle shots sounded as if we were on a hunting expedition.

We eventually reached the site of the Tomb of the Unknown Soldier in the heart of the city. Nearby on our left, in and out of the Grande Bretagne hotel, there was pandemonium though it was two o'clock in the morning. All the rooms were lit up, and motorcycles,

jeeps, red beret soldiers, and military police were everywhere. We were informed the following day that Churchill and Mountbatten were coming on a two-day "visit" to Athens.

The convoy turned right again past Parliament House toward the Royal Palace. When we arrived in the vicinity of the palace the convoy came to a halt. The mechanized vehicles were then sent in different directions to take up key positions. As soon as this was done, we fell into platoons in full battle readiness and saw the first Greek officers. Some were from Rimini, and others were among the ones that had remained in Greece during the German Occupation and had not fled to the Middle East.

It was then that my captain summoned me.

"Listen," he said, "We are five platoons of forty men each, and I am short of one officer to lead them. You are the only teeth-arm sergeant major; the others are support ones. So you will lead the fifth platoon and will receive your orders."

I saluted and left. In the army, it is well known that you don't argue; you just execute orders. On my way to take over command of the platoon, I was thinking: Good-bye home, good-bye mother, good-bye dreams. It is inconceivable to fight just 150 meters away from your house! And what sort of warfare are we talking about? It seemed more like a Punch and Judy show to me. One saw some of these guerrillas on the opposite side of the town's dried up riverbed. Other than some World War I rifles, they were unarmed. I couldn't digest what we were fighting about and why our differences couldn't be ironed out. These, of course, were the naive thoughts of a twenty-year-old, but when I later witnessed the hatred and brutality on both sides, I realized the awful reality of a Civil War.

Luckily, my platoon was mostly comprised of chaps from El Alamein and some from Tobruk, whom I had no problems with. Our orders were to safeguard the whole area behind the Officers Club. A bad spot farther down was the Stadium Bridge from where most of the guerrilla attacks were launched. Still, forty experienced men were

more than enough to deal with the situation.

Thank God we had no casualties except for some isolated cases like a strange type of bullet that shattered the knee of one of my men. His leg had to be cut off.

In any case, the guerrillas launched a large-scale attack only once, on the night of December 18. About three hundred, maybe four hundred of them came down the dried-up riverbed, but I saw through my binoculars that they had no support fire. Other than their rifles, they had nothing—no machine guns, no bazookas, not even light submachine guns. There was no need for us to give battle, for it was obvious by the way they were coming down all clutched together that none would come out of there alive. I gave the order for all of our flamethrowers to be lit so that they realized it would be impossible for them to approach this wall of fire. We also fired a few bazookas at them and threw some flares, which turned the night into day. They must have understood these warning signals and that it would be plain suicide for them to cross the ravine and come up to face us, and therefore they retreated to their positions.

The following day, I was asked to report to my CO and explain my not having wiped out all the guerrillas and instead warned them off. I explained in detail my actions, and this exceptional and brave man told me, "I would have done the same." He continued, "Brave men do not kill civilians, for, irrespective of their hatred for us, as far as we are concerned they were practically unarmed."

I found then the opportunity to discuss with him the possibility of visiting my home. He told me that all the flat roofs of buildings on the way, like the Evangelismos Hospital and the Maraslion Academy, which cannot be checked, were full of snipers who would hit me as soon as they saw me. I answered that I would go very quickly by jeep at night…

"And who will you leave with your platoon of savages?"

"I can leave them for one night with Focas, who is also a

sergeant major."

"That is all we need now—to entrust the platoon to the Alexandria aristocracy! Be patient. In three or four days, this story will be over."

What could I tell this man, when I had already for the last ten days been five minutes away from my home but could not get there and all he had to say was for me to be patient for another three days—and this without any guarantees?

Actually, things did calm down, and there was no activity from the opposite side. The ELAS force must have abandoned their position, and indeed within three days, on Christmas Eve, my captain said to me, "At midnight, take the jeep, go to your house on the double—alone—and be back at five o'clock in the morning. Ask Focas to replace you but no one else is to know of your absence. Take care, and be back before dawn, for it will be a great pity if after all you have been through you get it from a flat roof in Kolonaki."[36]

He smiled. I informed Focas of my whereabouts and at midnight drove up Queen Sophia Avenue and across to where the British Embassy was. The avenue was completely deserted of passersby and cars. The embassy was guarded by English red beret men, and at the front of the building a tank was blocking half of the street. I was flagged down by an English soldier who approached and seeing my uniform just asked me to put my helmet on due to the snipers.

I did so as the soldier was quite right, and I quickly drove uphill to the street my house was on. Not a soul there either. I parked the jeep halfway up the pavement under a tree just outside the doorway and rang the bell only once, lightly so I wouldn't scare them. I was shaking all over, not out of fear, for the thought of getting killed on the street seemed ridiculous. I was shaking with emotion for what will happen next. I carried with me a bag full of cigarettes, soaps, and chocolates. I had no idea of their needs, if they had no bread, needed tins of food, or whatever else. I would make sure and bring it all the

36 *Exclusive Athens residential area*

following night.

The door did not open, so I rang the bell again. This time I heard a voice coming from the fifth-floor balcony.

"Who is there?" It was my sister's voice.

"It is me," I answered. Their loud voices could be heard in the street as they all came out on the balcony at the sound of the doorbell. They had obviously received my letter from Italy, knew I was alive, and were expecting me.

The door at last opened, and I ran up the stairs, bag in hand, to the fifth floor as there was no electricity…There on the landing the scene was unique. All the love, anxiety, privation but also the joy expressed themselves in my mother's embrace. Then it was my sister's turn. With her, the embrace and the tears had a different meaning, for in me she saw her husband who would never come back. Finally, it was my father's turn. He kissed me, looked at my chest, saw my six medals, caressed them and said, "Bravo." He had also fought in another war and knew how one gained these colorful little ribbons.

We went in and sat in the drawing room. I was looking around and couldn't believe that after four years of waiting this moment had arrived and I was living it, not just dreaming of it. We talked a great deal about our experiences and all that happened during these four years. For example, I had sent to my family, at the beginning of 1943 after El Alamein, a cable through the Red Cross in Cairo. They had never received it but my mother had heard about the battle over the BBC. On the *This is London* program, she heard my name among other names given during the Red Cross hour. These were my mother's heroics, for these wavelengths on the radios were sealed off by the German authorities, and the punishment was imprisonment, even death if one tampered with the seals.

Time was passing by, and it was almost four o'clock when my father said to me, "You know, our summer house in Kifissia has been taken over by ELAS guerrillas. Our gardener who managed to get

here has informed us that they are wrecking it by burning furniture in the fireplace so as to keep warm as well as other acts of vandalism."

Before my father had finished his phrase, my mother, who was scared for my life but possessed a great sense of humor, began to shout at him, "What are you telling our son. He has hardly returned from war and you expect him to go and lay siege and take our palazzo by surprise to save our furniture? Who cares, as if we have brought over our furniture from the Versailles?" Of course, my mother was saying this in case I went and put my life on the line to get the brigands out of the house.

I left with the promise that I would be only a few steps away, that the situation was clearing up, and that I was no longer in danger.

True enough, after three or four days it was all over. All over in Athens, that is, but not in the suburbs and certainly not in the rest of Greece where guerrilla fighting went on until 1948. We ourselves had only seen the end of it in Athens as we arrived on the December 18, and the Civil War began on the fourth.

Remembering the conversation I had with my father regarding our house in Kifissia, I thought of going there to see what was going on. Just in case, I took three of my men along—of those who fought the Germans man-to-man with bayonets in the Tobruk boxes. Not that I intended to give battle in order to get my house back, but as things stood at the time, you never knew what you could come up against. We arrived in Kifissia where it was rather quiet. At the house, the garden gates were open as well as the door of the house. I entered, followed by my men with machine guns at the ready. I ordered them not to scatter in the rooms to avoid isolated skirmishes that would turn the house into a battlefield.

In the large sitting room, no more resembling the room I once knew, planks of parquet wood were all over the place, as were broken chair legs and some armchairs and other furniture not belonging to

us. The bearded men were lying in two of these armchairs, and as soon as they became aware of our presence they jumped up, grabbing their rifles. One of my men advanced on them with his machine gun and disarmed them.

They seemed to relax a little, and I went on, "Who is your leader?"

"Call him". "He is upstairs". "How many more of you are there?"

"Two more, but they are outside."

"Good." I left with two of my men to guard them and, addressing everybody, said, "Behave. I don't want any blood spilled all over the house…"

I went upstairs to the bedrooms with my man Andreas. I found no one, but when I entered my parents' large bedroom I found a bearded man around forty years old lying on my mother's bed, snoring.

Before I was able to speak, Andreas stuck the barrel of his Tommy gun on the man's cheek and said, "Wake up, smart guy. Your hotel days are over."

The man jumped up—two meters tall—trying to get his gun, which he had left on the side table but which I already removed. Andreas added, "Take your greatcoat with you; you are not coming back here."

The man looked at me furiously and walked to the staircase. The way Andreas was pointing the machine gun at him there wasn't much he could do. Once in the sitting room he saw his two men standing silently and understood that he no longer had the upper hand.

I turned and said calmly to him, "We haven't come here to kill anybody. What I want is for you to take your belongings and empty the house now. You are the leader?"

"Yes."

"Then get your other two men who are outside and go back to your unit, not to other people's houses that do not belong to you."

"Has a brigade unit come up here in Kifissia?" he inquired. "No," I answered.

"Why, then, have only you have come to this particular house?"

By then, Andreas who was getting annoyed seeing me getting into a conversation with this man and in an irritated voice told him, "Are you interrogating us now? Well, hear this: the house belongs to him, and you have wrecked it. So get on; get out of here."

By now this conversation was taking place out in the garden. We had removed their guns, and all they were left holding were their blankets. The leader did not seem much of a fanatic. Especially after Andreas told him the house was mine.

He muttered in a low voice as he was leaving, "Sorry, Sergeant Major, sir."

We nailed some planks on the windows they had broken to enter the house, as well as on the front door to secure the house, and left. If my mother should walk in and see the state of her house she would at the very least have a heart attack, I thought.

The Civil War was over, at least in Athens, and I was able to go home and sleep there every night—what bliss—in my own bedroom, in clean sheets, and with heating I managed to provide by filling the petrol reservoir as soon as the troubles were over. So in the morning, after having a nice cup of tea, I went to my unit like a gentleman—clean, neat, and freshly ironed. I couldn't possibly have dreamed of such well-being and comfort only two months ago. One cannot image any of this if one has not experienced it. This is why today's youth, when they happen to see a movie on these events, cannot believe any of it and think of it only as a good film, a film in all its terrific greatness.

After the storm comes fair weather; 1945 was the year of rest for the soldier. I unloaded my little Fiat from the crane, and this car

proved very useful, as I couldn't take the ladies around in a military jeep. Meanwhile my captain was transferred to the general chief of staff and took me with him. I was working like a prince would. I went there in the morning and was back home for lunch and for fun in the evening. I also rented my own flat in Kolonaki, which soon became the center of merrymaking and debauchery. In a very short time, all the other residents in the building had to move so as to be able to get a good night's sleep.

Only Takis Horn[37] did not move out as he often joined us during those memorable evenings. With me in this flat lived Pyrros Spyromilios, Andreas Kouroussopoulos and a Russian guitar player named Christopher. Pyrros could not leave in the morning to join his ship at the Naval Base if, while drinking his morning coffee, Christopher did not play for him the tune "Hail my gypsy brothers". Now what was the connection between Pyrros from the north of Epirus and the gypsies who no one ever understood? Also. that flat witnessed the birth of the great love affair of Pyrros with Melina Mercouri, in her early twenties at the time.

1945 was an outburst after the war. Subconsciously, it was the joy of having survived while so many others had not. It was only human. I got drunk in 1945 and sobered up in 1950.

37 A jeune premier at the time and later a great actor.

THE RETURN OF THE GENERAL'S DAUGHTER

One day early in 1946, at noon, while I was still serving in the army, my mother phoned me at my flat saying that her doorbell rang and out of the blue stood at the door "a very good looking lady speaking only French, who insistently maintains being your wife". "I am sorry", I answered, "I forgot to tell you, as I did not wish to upset you". My mother's sense of humour, especially during a crisis, was unprecedented. "In that case come and get her, as your father will come home any time now and if he hears that there is another addition to the family, he will think of the extra expenses and will lose his appetite, and not be able to have his lunch".

Simone fell like lightning on my head. She settled of course in my flat and turned us all upside down. She did not want anybody else in the house, which I did not agree with and which was the cause of perpetual quarrels. Amidst the upheavals, my Captain announced that the orders of my discharge and those of all the other Middle Eastern men were issued, and that on Monday I must go and get my release papers from the army. I was overjoyed!

So on Monday morning I presented myself at the office to which I was directed where, behind his desk, sat a Colonel. I recognized

from his uniform that he was one of those officers who had not fled to the Middle East, but had stayed in Greece during the German Occupation. "Good morning", I said, with the familiarity I had been accustomed to with our own officers. "I have come for my discharge papers", I continued with a smile. He looked at me with a nasty look in his eyes, and said: "Why aren't you wearing your kepi, and why aren't you saluting as you should when entering a Colonel's office?" "I am sorry Colonel, sir", I answered, realizing what I had come up against. "I consider myself honourably discharged, that's why". "You have not been discharged as yet nor will you be for some time". I was taken by surprise and began to flare up.

Before having a chance to tell him I did not understand the meaning of his words, he called out loud to someone outside the door and in came a boor of a Sergeant. "Take him to the detention cell on a twenty-day confinement for improper behaviour to a high-ranking officer", he shouted. I went berserk, and rightly so for his uncalled for reaction, regardless of the known dislike these officers had for us Middle Easterns. The boor Sergeant tried to grab my arm. I was roused with anger. "Hands off or I'll bump you off right here and now!" He got worried and let his hand fall, while looking at the Colonel who got up form his desk howling "Don't you dare bully us in here, for I will personally take you in chains to where you are going".

I quickly thought I must find a way to notify my C.O. at the General Chief of Staff headquarters to get me out of here. So I turned around and said: "I don't know where you fought your war but you know where we did, so no wonder you have a chip on your shoulder" and, before he had a chance to react, I turned to the Sergeant and said, in a commanding voice, "Come on, you take me to the detention ceil". A scared Sergeant led the way to some kind of old torture chamber full of mice and cockroaches, now used as a detention cell. As soon as he locked me up he said, in a whispering voice, "Sorry Sergeant Major, sir. You have no idea what sort of a person you have to deal with. You did very well speaking to him as you did". "Come

back" I told him, taking some bank notes out of my pocket. He was afraid to take them. "Take these", I said, writing on one of them the private phone number of my Captain. "Ask for Captain Dimopoulos, tell him what happened and he will know what to do". "I will go now to the kiosk Sergeant Major, sir, and place the call, for I don't dare do it from here." "O.K.", I said, and sat on the damp stone bed thinking what sort of people there are in this world.

Here is a man who reached the honourable rank of Colonel— and I could remember our own Colonels in the front lines of El Alamein and Rimini—after all, Katsotas and Tsakalotos were Colonels too. How can one compare these giants with this incompetent man only capable to show his fierceness when bringing out his inhibitions at the first given opportunity.

Luckily, he was an exception among the Greek officers. All this kept going round and round in my head when suddenly I burst out laughing. I just imagined Simone looking everywhere for me, believing I was with one of my girlfriends as she often accused me for. At least two hours had gone by when I heard some commotion and shouting. I discerned Dimopoulos' voice in a tone I had never heard before. Obviously, the Sergeant must have phoned him at once and Dimopoulos went as high as the Major General explaining who I was and what had happened, and was given a written order for me to be released at once.

The door of my cell opened and I saw Dimopoulos with the Colonel right behind him. Dimopoulos had already been issued with my discharge papers, and said to me: "Come on, take your papers and move on". I cast a killer look full of irony to the Colonel and heard him say to my Captain: "We will have a talk again soon", to which Dimopoulos answered: "I hope never to cast my eyes on you again", adding: "and so should you".

This is the inglorious tale of my military discharge, which is proof of the devious character of the Greeks on one hand and all the gallantry on the other. When I related these events to Simone, she

was taken completely aback. "What wonderful people you Greeks are", she said, "imprisoning your heroes ". To avoid any misunderstanding, the hero to whom she referred was me...!

Despite our quarrels, Simone of course stayed at my flat "according to her rights", as she often said. Granted, she had every right to do so being my legal wife, but to set the record straight she wanted to live alone with me, and not with my noisy naval officers and the Russian singer.

Life was not sweet for Simone, who no longer had the splendor and grandeur of the being the General's daughter and had turned into a middle-class French woman with all the bourgeois characteristics that go with it.

With my friends Spyromilios and Kouroussopoulos, I often held conferences, away from home, as to how to get Simone back to France in a subtle way, seeing that her father was no longer High Commissioner in Lebanon and lived now in France as a discharged veteran. During these meetings Kouroussopoulos was in favor of a compromise solution: "She will get sick and tired of all this fighting, and one fine morning she will leave by herself."

Spyromilios reacted, "You are naive."

He yelled at him, "Now that she found the goose that lays the golden eggs, you think she will ever leave? You are crazy! Leave it to me. I will put her on a ship pretending I am sending her on a cruise to the islands—she wants to go there anyway—and the ship will be going to Marseille."

"And when she sees Marseille," I interrupted, "she will be back on the same ship."

"But I will not send her alone. Two of my sailors will escort her and will… take care of her."

Of course, none of these solutions were feasible or realistic. Lady Destiny herself took things in hand, knowing exactly what she had to do. Six months went by—six months of friction and quarrelling.

My friends, of course, remained at home. We only gave in a little by getting rid of Christopher and his morning concerts. We sent him packing but often went to Chez Lapin[38] to listen to him singing.

One night we went out together, plus Spyromilios's girlfriend. We had booked a table at a new plush nightclub opening that night in Kifissia. All five of us got in my car, a big Mercury I owned at the time, and arrived at this fantastic place. We were given the best front row table next to the dance floor, and the place was mostly lit by candlelight.

Simone, as per usual, picked a fight again on the same refrain: "Why can't we ever go out alone for a romantic evening without taking along the entire Royal Navy?"

All of this while she downed one glass of whisky after another. At some point a group of dancers made their appearance, Simone relaxed, and we managed to enjoy ourselves. When the dancers finished their number, a cultured pianist came in and began to scratch on the piano several American melodies without playing a specific tune; it sounded more like an introduction. Then in the semidarkness a woman appeared, walked to the piano, and leaned on it. The pianist stopped fooling around and began playing something else. Simultaneously, the spotlight was turned on and shone on the singer. She was a tall blonde with blue eyes wearing a long black dress with a daring décolleté.

She was a beauty, she was a goddess, she was…Yuki. Yes, my Yuki from the war days in Alexandria. Yuki, with whom I experienced the most erotic month of my young life, the one I left without being able to say good-bye to because of that ridiculous commander who sent me handcuffed from Cairo to Palestine. That sweet creature I felt so guilty about, never heard from again, and was sure I would never see again.

Yuki stood right there in front of me. I was flushed, sweating;

38 A seaside nightclub

my legs were shaking. There was no way she could have seen me with that strong spotlight shining in her eyes. She began singing a song that was popular at the time, "I'd Like to Get You on a Slow Boat to China."

In the meantime, my friends who knew about Yuki and our affair in Alexandria exchanged worried looks and then looked at me, wondering what would happen next. Simone, of course, hadn't caught wind of what was going on, as she had never seen Yuki before. But I was not the sort of rational guy who could pretend, waiting until after she had finished her show, then feigning going to the men's room and instead making a bee line for her dressing room. No, I was all for the shock produced by the lightning speed of a movie scene, regardless of the inevitable consequences.

As soon as she finished her song and before she could start on the next one, I shouted from where I was sitting, "'The Man I Love,' please."

Yuki seemed to freeze but couldn't possibly imagine it was me after all the years that had gone by. She approached our table and with a hurt expression said, "I have never sung this song again since—" and then stopped talking. She saw me! She put her hands up to her face to shade her eyes and stuttered, "Not you…" She then turned to the pianist who was not the one she had appeared with in Egypt but must have known her story and never played that song, and as he looked at her, surprised, she said, "Play it, Joe." She came near and began singing, "One day he'll come along, the man I love." It was just like that night at the Carlton in Alexandria. She sang only for me, and tears were in her eyes.

I was in shock, and nothing else mattered at that moment except Yuki, the song, and the memories. My two friends were ready to hold down Simone just in case she was about to make a scene, but she was completely at a loss, not understanding what was going on. Yuki could barely finish the song and left the stage running. I got up at once and followed her to her dressing room while Spyromilios and Kouroussopoulos tried to constrain Simone and explain the situation to her. My legs were shaking when I got to her door, and without knocking I went in and simply said her name, "Yuki." She fell into my arms without a word, just crying and kissing me. She didn't even

ask me, which would have been only natural, why I had abandoned her in Cairo. Not a word. Between her sobs all she did was try to tell me how one night, a year after we were separated, she had signed on with a club in Beirut and met there some Greek naval officers and asked after me. They told her they knew me, and one of them told her I had been killed in El Alamein. The tragic war stories...At that time I was also in Beirut, very much alive and getting married to a woman I wasn't really in love with and who was now outside waiting for me, while two men were holding her down to stop her from coming in here and tearing the place apart.

She was listening to all of this, eyes wide open. "And now?" she said.

"Now, I will tell you exactly what will happen." All the decisions made in my life were made on the spur of the moment, without much thought and regardless, as I said before, of the consequences. I left with Yuki through the back door and went straight to her hotel. Of course my friends realized after a while that I wasn't coming back to the table, nor was I coming back home. The next day I left with Yuki for Italy, and it was a long time before I came back to Greece.

The solution for Simone's departure, which we had tried so hard to find, came by itself under the name...Yuki.

Next night, we arrived in Taormina, Sicily, for the summer.

Love is always the winner in my life.

THE END

ABOUT THE AUTHOR

Zahos Hadjifotiou was born in Athens in the picturesque district of Plaka. He lived, as he himself often says, in a town resembling a theatrical setting.

At the age of seventeen, just out of school and right after the Germans occupied Greece in 1941, he fled to the Middle East and fought in Tobruk, El Alamein, and with the Rimini Brigade in Italy. After the war he got involved for a while with the family business but later left for Paris, where he lived for several years.

On his return to Greece, he took up journalism as a columnist in most of the prominent daily newspapers. He is the prolific author of fourteen books, some of which made record sales. He is also the author of verses put to music by distinguished popular musicians, has written plays for the theater, and has translated and adapted theatrical plays that were staged with success.

He has worked for twenty-three years on television and became famous for his daily five-minute political humor talk show.

He has traveled extensively, has taken part in car rallies, and always was and still very much is a ladies' man. He was deputy mayor of Athens.

Today, at the age of ninety-something, he appears on many television talk shows and still drives fast cars…

BOOK REVIEW

"A World War II veteran recounts firsthand horrors on bloody battlefields and passionate liaisons in Middle Eastern nightclubs as a Grecian soldier.

Hadjifotiou's (*Games of Passion in Mykonos*, 2015) life was interrupted by war, with Mussolini's invasion of Greece spurring him to leave home and join the fight against the Axis powers. He enlisted in the British army and found himself in the port city of Tobruk, Libya. Here, he was one of history's famous "Desert Rats"—men who spent eight months of hell under siege by Field Marshal Erwin Rommel's troops: "Thirty-five thousand wounded and several thousand dead." Hadjifotiou's reputation as one of Tobruk's heroes afforded him numerous promotions and military decorations. He was eventually assigned to pilot a crane named "Mac" to salvage Allied vehicles and save trapped soldiers. Between the siege and battles against German forces in both El Alamein, Egypt, and Rimini, Italy, he spent many of his nights with fellow soldiers acting out in the urbane nightclubs of Egypt, and later Beirut, seeking pleasure and luxury with alcohol and women. The author recalls his wartime adventures with a dry romanticism, never shying away from his experiences, be they vodka-fueled nights or hand-to-hand combat on the battlefield. Hadjifotiou is short-tempered and apolitical, prone to nostalgia in unex-

pected ways—the soldier recalls his crane with more sentimentality than his whirlwind marriage to a French general's daughter. When reunited with his lost love, Yuki Russell, a Jewish-American singer he met early in the war, his enthusiasm will likely seem shocking to some, as he seemed to have all but forgotten her before. There's no sugarcoating these oddities, no rationalizations made for these arrogant or reckless turns any more than for the heroic ones. The closest the book comes to indemnifying the actions of any—from womanizing to looting—is to maintain that those who were not there cannot know. The autobiography is remarkably concise, perhaps to its detriment—it's unlikely readers will feel transported to nightclubs or war zones with its minimalist approach.

A pithy and unapologetic memoir, as much about the good times of war as the bad."

— *Kirkus Reviews*
August 19, 2016

www.ingramcontent.com/pod-product-compliance
Lightning Source LLC
Chambersburg PA
CBHW071346080526
44587CB00017B/2987

PRAISE FOR VERONICA HODGE

How to Organize and Clean Your Home For Adults with ADHD is an ADHD-friendly organizing guide that respects how motivation and time perception actually work, turning clutter into a workable, sustainable system.

> DR. MAYA CHEN, CLINICAL PSYCHOLOGIST AND ADHD SPECIALIST

This book's actionable steps—designed for actual homes—let readers start today and reframe cleaning from a crisis into a calm, repeatable process.

> JORDAN PATEL, CERTIFIED ADHD COACH AND FOUNDER OF FOCUSFLOW COACHING

Partners and families gain compassionate strategies to support without triggering shame, transforming shared spaces into collaborative, low-friction environments.

> DR. HANNAH REED, PROFESSOR OF BEHAVIORAL PSYCHOLOGY